WILTSHIRE'S
MILITARY HERITAGE

WILTSHIRE'S MILITARY HERITAGE

Andrew Powell-Thomas

AMBERLEY

For Richard E. Flagg, with thanks.

First published 2023

Amberley Publishing
The Hill, Stroud
Gloucestershire, GL5 4EP

www.amberley-books.com

Copyright © Andrew Powell-Thomas, 2023

Logo source material courtesy of Gerry van Tonder

The right of Andrew Powell-Thomas to be identified
as the Author of this work has been asserted in
accordance with the Copyrights, Designs and Patents
Act 1988.

ISBN 978 1 3981 0313 9 (print)
ISBN 978 1 3981 0314 6 (ebook)

British Library Cataloguing in Publication Data.
A catalogue record for this book is available from the
British Library.

Origination by Amberley Publishing.
Printed in Great Britain.

Contents

Introduction

The land-locked county of Wiltshire, one of the largest counties in southern England, has rolling hills, national parks and vast swathes of farmland. Much of the county is comprised of high chalk downland, most famously on Salisbury Plain, as well as wide valleys and vales, often with rivers running through them. In the north-west, Wiltshire runs into the Cotswolds and south-east Wiltshire lies on the edge of the New Forest. It has a rich military heritage, so much so that it could be easy to live or commute in Wiltshire, particularly if on holiday, and not see or appreciate the sheer range of history that lies all around, often in plain sight.

Unsurpassed in its ancient sites, there are countless Iron Age hillforts dating back to before 500 BC scattered right across the length and breadth of the county – thanks to the numerous natural hills that roll across the countryside, and some of these vast earthworks are still visible as outcrops of land. Castles and fortified manor houses sprung up over the centuries as defensive centres of power for the rich and powerful and were used to keep the locals in check. Areas where skirmishes and battles were fought between Royalist armies representing the King of England and local rebels and Parliamentarian forces during the English Civil Wars are now just empty fields with livestock grazing peacefully in them.

Military bases developed, and The Wiltshire Regiment, now amalgamated as The Rifles, has its museum in Salisbury, ensuring its proud and vast history is shared. The names of hundreds of young men who set off from the quiet life in Wiltshire, never to return from the horrors of the First World War, are immortalised on the silent monuments that adorn nearly every town and village. Then of course there's the Second World War, which saw armament factories, camps, defensive emplacements, as well as prisoner of war camps, built the length and breadth of the county. This is not to mention the large number of airfields that were built for training and formed part of the strategic defence during the Battle of Britain. The industrial centres faced German aerial bombardment, particularly Swindon, and the county saw an influx of servicemen and women as the Allies prepared for D-Day using Wiltshire's vast array of airfields as an essential component for the logistical and operational movement needed for the liberation of Europe.

Wiltshire's proud military heritage continues to the present day, with airfields, military camps and training centres, such as Salisbury Plain, still in use by Britain's armed forces.

This book aims to provide some background and insight into the range of localities right across the county, looking at their roles and what can be found there now. It is organised according to geographical location, using the established parliamentary districts of Wiltshire.

1. North Wiltshire

Ashton Keynes Castle

Built in the twelfth century by the Keynes family to help maintain law and order over the locals, this fortification was thought to have been a cross between a ringwork defence and a motte-and-bailey castle. Some historians think that this might be the castle that was captured by King Stephen from Miles of Gloucester during the Anarchy of 1135–53. Excavations over the years have revealed some fragments of pottery and floor tiles, but sadly, nothing now remains of this castle except some earthwork ditches.

Bincknoll Castle

Located to the west of the village of Wroughton, Bincknoll Castle is the site of an Iron Age hillfort, although some suggest its origins are from a slightly later time. In the aftermath of the Norman Conquest, Gilbert of Breteuil became the owner of manors around the Broad Hinton area, and it is thought that he built a castle on this older site to oversee them. It is easy to see why. The steep natural banks provide very good natural protection, and the earthworks that remain there today indicate that a motte-and-bailey castle was built here with two ditches, each over 2 metres in depth, adding to the already strong defences. The need for the castle diminished over the years, and everything that could be reused elsewhere was, meaning that today, only the steep earthwork remains of the enclosure are still there.

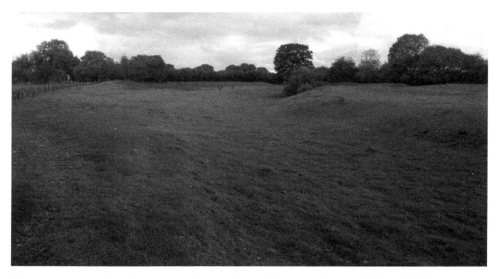

The remaining earthworks of Ashton Keynes Castle. (Courtesy of Martin Elliott CC BY-SA 2.0)

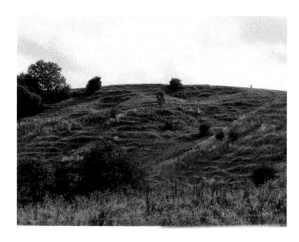

The steep banks of Bincknoll Castle.
(Courtesy of Brian Robert Marshall
CC BY SA 2.0)

Castle Combe Castle

Built by Reginald de Dunstanville in 1140 on the site of an entrenched Celtic camp that was abandoned when the Romans took control, Castle Combe Castle sits half a mile outside the village of the same name. On a commanding position overlooking the valley, the summit covers around 8 acres and is surrounded by a defensive ditch, and this coupled with the steep sides would have made this a difficult place to capture. As the centuries passed, the need for a fortified defensive position waned, and the castle gradually fell into disrepair as the Manor House was built in the fourteenth century. Although the site today is overgrown, some of the earthworks are still visible, and it is believed that some stonework is located in the undergrowth.

Malmesbury Castle

The town of Malmesbury was an important trading settlement in the medieval period, no doubt helped by nearby Malmesbury Abbey, and unsurprisingly, it once had a castle. In the twelfth century, a motte-and-bailey castle was constructed close to the abbey by Bishop Roger of Salisbury. However, in 1139 King Stephen of England was concerned about the loyalty of many bishops – Roger included – and decided to seize Malmesbury Castle for himself. Soon after this, the civil war known as 'the Anarchy' began, and local Baron Robert Fitz Hugh took control of the castle from King Stephen. Unsurprisingly, the King sent out a force to retake the castle, which they did not long afterwards, and pillaged the town in the process, causing much bloodshed. The Royal troops then used the castle as a base to raid the local area, surviving a siege attempt by Robert of Gloucester in 1144, and it remained under royal control until after the civil war. In the early thirteenth century, King John received a petition from local monks and agreed to have the castle destroyed, and today there is nothing left of the castle, and no clues as to whereabouts it was in the modern town.

RAF Blakehill Farm

Constructed in 1943, RAF Blakehill Farm was a three-runway airfield built during the Second World War as the allies turned their thoughts from the defence of the country to

the liberation of Europe. Opened in 1944, No. 46 Group RAF Transport Command was based here throughout the remainder of the conflict, providing vital logistical support for the allies by assisting with the movement of materials, supplies and men. No. 437 Squadron Royal Canadian Airforce, 233 Squadron RAF and men from the Glider Pilot Regiment all flew from this airfield. By the end of the war the role of the airfield was significantly reduced, and it became a satellite airfield of RAF South Cerney – being a training centre until it was closed in 1952. After this, it is believed that GCHQ set up an experimental radio station here, with huge communication masts placed in the middle of the airfield. Much of the site was returned to agricultural use, and today it is a Wiltshire Wildlife Trust nature reserve, with just a few glimpses of its military past.

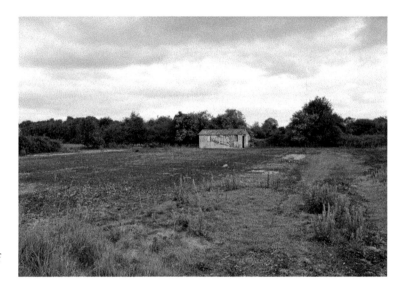

The partial remains of one of the runways of RAF Blakehill Farm. (Courtesy of Richard E. Flagg)

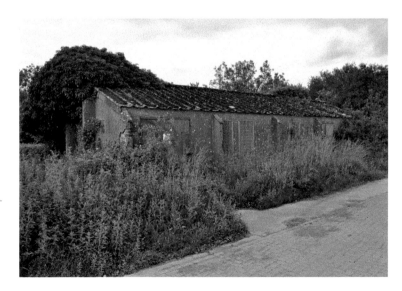

Just a few buildings lurk in the undergrowth – gradually being reclaimed by Mother Nature. (Courtesy of Richard E. Flagg)

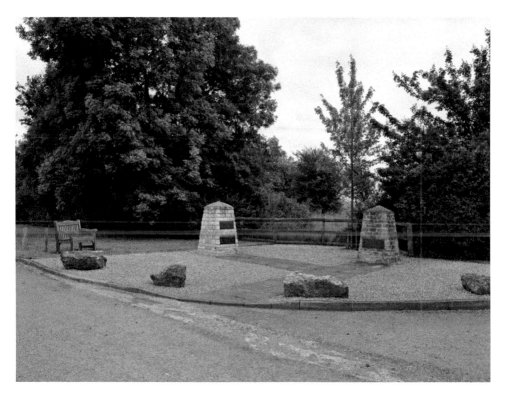

These memorials at the old entrance to the site stand as testament to the brave men and women who served here. (Courtesy of Richard E. Flagg)

RAF Castle Combe

Built on the land of the Castle Combe estate in 1941, this airfield of the same name occupied a site on the edge of the village for seven years. It was mainly used as a training centre and practise landing ground for pilots at the nearby RAF Hullavington, and No. 9 Service Flying Training School was set up here. With waterlogging a constant problem for the original grass runways, the airfield was one of the first to use 'Sommerfeld Tracking' – a type of wire mesh – for two of its runways. This allowed considerably more training to take place, and as a result, the whole site was extended and upgraded, to include a tarmac perimeter track, five hangars and a range of associated buildings and stores.

Decommissioned in 1948, the perimeter track was opened in 1950 as Castle Combe Motor Racing Circuit and continues to host a number of events to this day.

RAF Colerne

Built in 1939 on the outskirts of Colerne village, this 110-hectare site was used by RAF Fighter Command during the Battle of Britain, as a satellite base for RAF Middle Wallop. Over thirty different squadrons were stationed here between 1939–45, with Spitfires, Hurricanes and Mosquitos taking off around the clock to help defend Britain from the Luftwaffe threat. The airfield was a real hive of activity. As the war progressed, a number of squadrons also used the base to regroup before heading off elsewhere, like No. 89

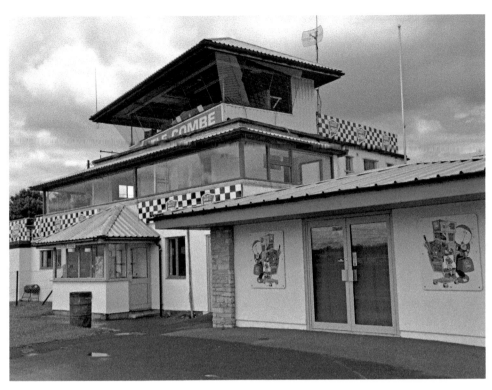

Some of the original buildings of RAF Castle Combe have found a new lease of life as part of the racing facilities. (Courtesy of Richard E. Flagg)

Squadron stopping here en route to Egypt. No. 238 Operational Conversion Unit was stationed here and used the facilities as an essential training station for Night Fighter navigators, with Bristol Brigand twin engine aircraft being used for this. After the Second World War, the RAF kept the base operational, with No. 49 Maintenance Unit RAF calling it home from 1948 to 1962, where they specialised in the de Havilland DH.82 Tiger Moth, as it became a Transport Command airfield. The newly introduced (1948) Handley Page HP.67 Hastings troop-carrier and freight transport aircraft were flown and maintained here, and major servicing of the Lockheed C-130 Hercules (1956 onwards) was carried out at RAF Colerne by the Air Engineering Squadron. No. 2 Field Squadron RAF Regiment was stationed here from 1962 to 1975 and adopted a parachute capability. Throughout their time at Colerne, they were often tasked with internal security operations in Northern Ireland, Cyprus, Aden and Oman. The RAF closed the base in 1976, but it was subsequently taken over by the British Army, who used it as a training facility for the Junior Leaders Regiment of the Royal Corps of Transport and Royal Army Ordnance Corps. Still used by the army today, the airfield is the current home to 21 Signal Regiment, Royal Signals, the 93 (City of Bath) Squadron Air Training Corps and the Bristol University Air Squadron (BUAS) who operate a flying training role for the RAF. Colerne Airfield is used by other military cadet units for training purposes, meaning that it is very much an active installation today.

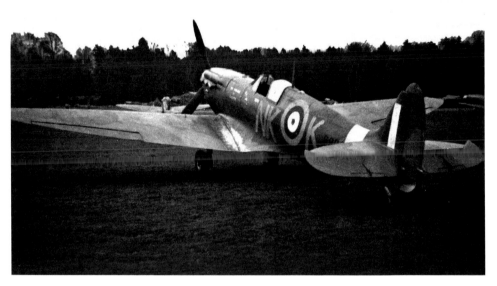

A Supermarine Spitfire Mk IIa at RAF Colerne in 1941. (Courtesy of the Dave Welch Collection)

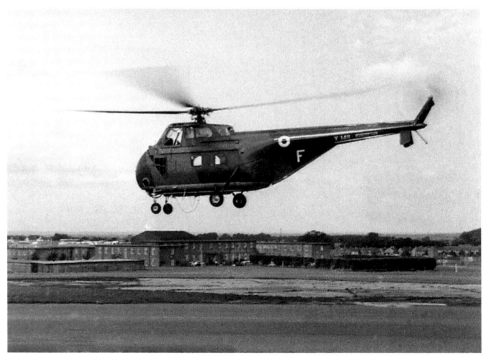

A Westland WS-55 Whirlwind at RAF Colerne in 1961 as part of the Battle of Britain display. (Courtesy of Mike Dowsing)

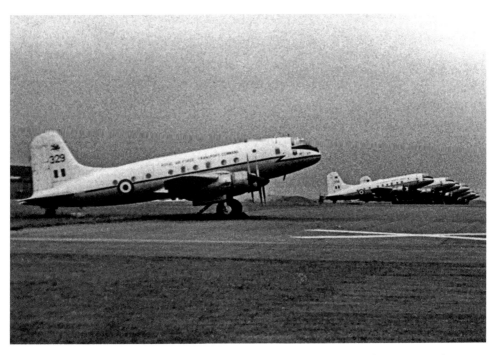

Handley Page Hastings of No. 24 Squadron Transport Command at RAF Colerne in 1967. (Courtesy of Ruth AS CC BY 3.0)

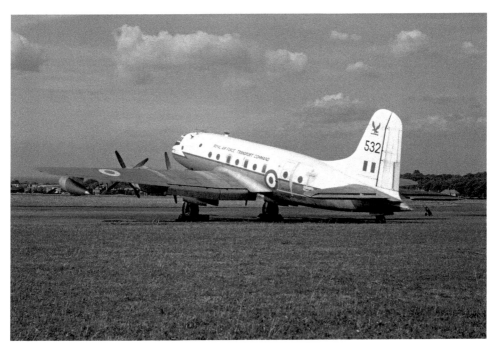

A colour photograph of one of the Handley Page Hastings based at Colerne in the 1960s. (Courtesy of Adrian M. Balch)

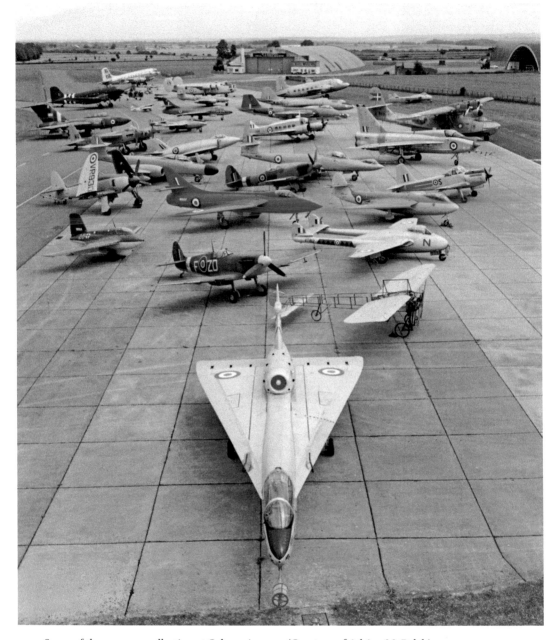

Some of the museum collection at Colerne in 1975. (Courtesy of Adrian M. Balch)

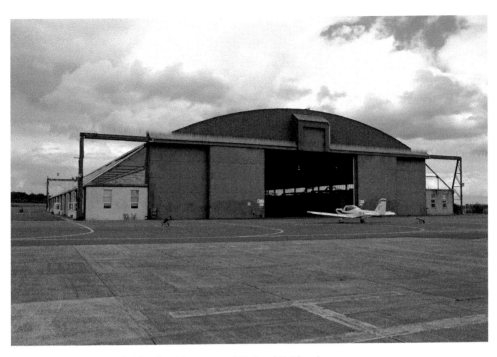

The site of Colerne Airfield today. (Courtesy of Richard E. Flagg)

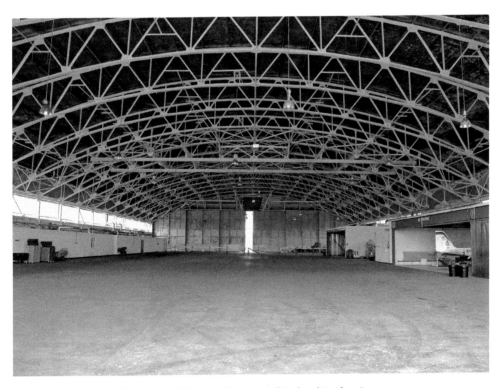

Inside one of the huge hangars at Colerne. (Courtesy of Richard E. Flagg)

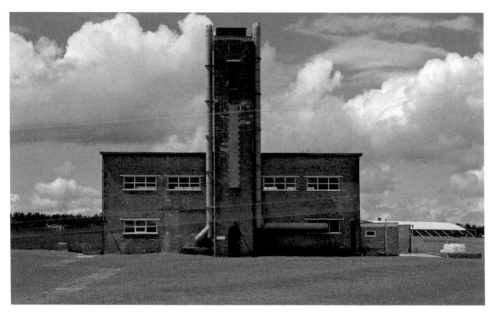

Some of the older structures of RAF Colerne still stand. (Courtesy of Richard E. Flagg)

RAF Compton Bassett

At the height of the Second World War, RAF Compton Bassett was built and opened in 1940, just a mile from the town of Calne, and close to the already existing RAF Yatesbury. It had no airfield as it was a radio and radar training school and many developed their skills and knowledge here. After the war, it remained open as a 'trade training camp' for certain ground Signals trades. Thousands of new RAF recruits learnt their RAF trade skills here, becoming competent Wireless Operators, Radar Operators PPI, Teleprinter Operators, Telegraphists or Telephonists before being posted to work at RAF operational stations and airfields elsewhere in the United Kingdom or abroad. No. 3 Radio School RAF moved here until the station was closed in the 1960s. However, the housing on site was still used by RAF staff working at RAF Lyneham, and in the 1980s, it was used for US Air Force staff working at RAF Fairford and RAF Greenham Common, before being sold off as private residential buildings and renamed 'Lower Compton'.

RAF Lyneham

In 1939, with tensions escalating and war with Germany imminent, the RAF searched for new potential airfield locations right across the country, and found one such site between Chippenham and Swindon. Initially built with grass landing areas, RAF Lyneham was constructed over a large area, with its hangars and associated buildings deliberately spread across the site to minimise the damage caused by any future bombing raids. Such was the size of the airfield, Lyneham Court Manor House and Cranley Farm needed to be demolished! Opening on 18 May 1940, No. 33 Maintenance Unit were stationed here, primarily fixing Bristol Blenheims and Airspeed Oxfords and over the next year, the grass runways were quickly upgraded to be more durable in all weathers – both

The original gates to RAF Compton Bassett still remain. (Courtesy of Richard E. Flagg)

One of the few original sections of the airfield that has not been knocked down and redeveloped. (Courtesy of Richard E. Flagg)

over 1,000 metres in length. In September 1940, the airfield was attacked by German aircraft, killing five workmen. October 1942 saw No. 511 Squadron RAF move here and they operated regular transport flights to Gibraltar and Malta. In 1943, as the allied preparations for the liberation of Europe increased, RAF Lyneham had a third, longer runway built (over 1,800 metres in length), and RAF Lyneham became the main airfield in the south for Transport Command. With this, 511 Squadron extended its long-range operations by flying the much bigger Avro York, delivering troops, supplies and materials to as far away as India. Being such a big site, it is not surprising that the RAF kept the airfield in operation after the war. 511 Squadron continued its work here until the 1970s, and No. 99 Squadron RAF reformed at Lyneham with more Avro Yorks. Like the 511, they performed a transport role, and both squadrons assisted in the Berlin Airlift and continued wider operations with Handley Page Hastings and Bristol Britannia aircraft. In 1956, 216 Squadron RAF came to the site, and because they were operating de Havilland Comet, the longest runway had to be extended by nearly 600 metres, to a length of just under 2,400 metres. With the Cold War at its height, in 1958, RAF Lyneham became one of eighteen 'dispersed airfields' across the country where the nuclear V bomber force (consisting of Avro Vulcan and Handley Page Victor aircraft) could operate from. In the 1970s, Lyneham took the new Lockheed C-130K Hercules (a large and hugely versatile transport aircraft) and became the main tactical transport base for the RAF, with 30 Squadron, 47 Squadron and 48 Squadron moving here. With 70 Squadron relocating here from Cyprus in 1976, Lyneham became the RAF's largest operational airbase. During the 1980s, many of the original buildings were updated/replaced and its role as the main transport base saw released British hostages John McCarthy, Terry Waite and Jackie Mann return here. In 1999, Lyneham received the first of the brand-new Lockheed Martin C-130J Hercules aircraft, but in 2003, it was announced that 'the RAF's air-transport and air-refuelling fleets would be consolidated at RAF Brize Norton', meaning the new C-130J fleet would move away. With the older C-130K fleet going out of service, all flying operations ceased in September 2011 and officially closed on 31 December 2012. The Defence College of Technical Training (DCTT) relocated to Lyneham in February 2014, providing training for all branches of the armed services, but now, it is currently used by the School of Army Aeronautical Engineering.

RAF Rudloe Manor

Located between the villages of Box and Corsham, RAF Rudloe Manor was initially built in the 1930s on the site of quarries that had produced tonnes and tonnes of Bath Stone. These tunnels, perfectly concealed from public sight, were initially used as a Central Ammunition Depot, with the vast underground chambers likely subdivided into smaller sections. This obscure location was developed during the Second World War, with the Operations Centre of No. 10 Group RAF being housed here in three buildings above the ground, although they were partially buried for additional protection. The Operations Room, initially stationed above ground near the main manor house before being relocated into an underground bunker in Browns Quarry, was directly responsible for directing all the RAF aircraft across the south-west of England and Wales. It was from here that channel convoys in the Western Approaches were protected, along with

the significant ports and naval dockyards in the region, including Plymouth. Before decisions were made here, The Filter Room, located in the southern end of the Browns Quarry bunker, was responsible for filtering the vast amount of enemy intelligence into concise information for the people in the Operations Room to act on. Also located in the Browns Quarry bunker was the Communications Centre, which was manned almost exclusively by members of the Women's Auxiliary Air Force and was responsible for ensuring messages got in and out promptly. This was the nerve centre of the air defences in the region and a vitally important cog in the defence of Britain. At the end of the war in Europe in May 1945 the Operations Centre ceased activities as No. 10 Group was disbanded with its job done. In the post-war years that followed, the site was used as Headquarters Southern Sector RAF, responsible for the administration and communications of the south of England, and recently released documents from the National Archives indicate that Rudloe Manor was the centre for all UFO investigations in the 1950s! From 1952 to 1980 it was also the Southern Area Headquarters of the Royal Observer Corps who, along with Headquarters Southern Sector United Kingdom Warning and Monitoring Organisation, were responsible for the 'four-minute warning' in the event of nuclear attack during the height of the Cold War. The site officially closed in the year 2000.

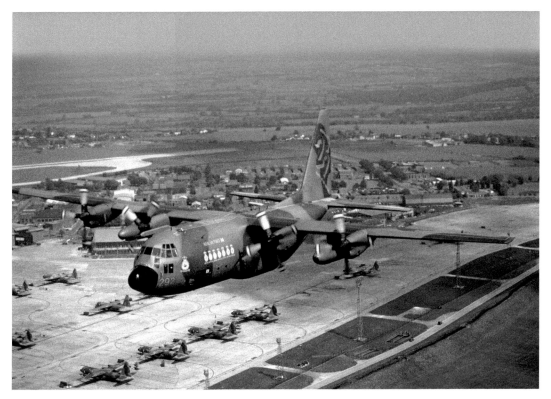

A stunning shot of a Lockheed C-130K Hercules flying over RAF Lyneham in 1992 as part of the 25th Anniversary of RAF Hercules 1967–92 scheme. (Courtesy of Adrian M. Balch)

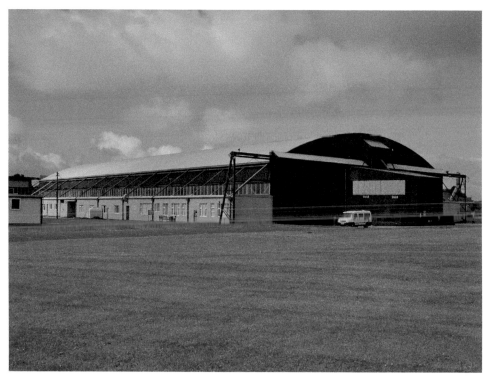

One of the many hangars that made up RAF Lyneham. (Courtesy of Richard E. Flagg)

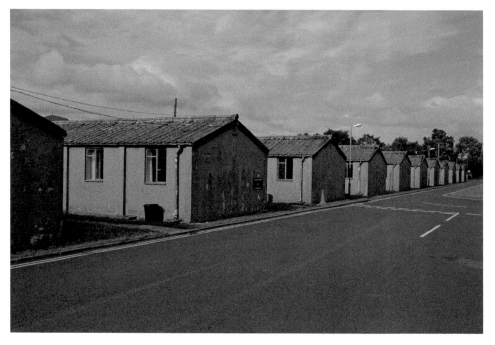

Some of the original buildings from the 1940s. (Courtesy of Richard E. Flagg)

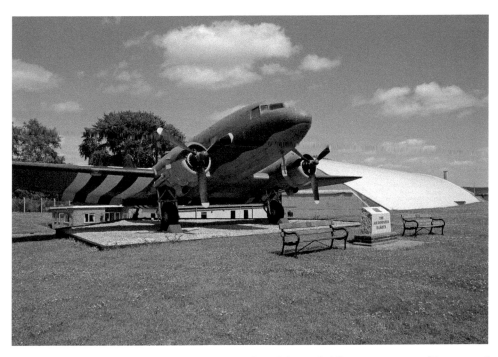

A Dakota transport aircraft stands as a reminder of the airfield's wartime past. (Courtesy of Richard E. Flagg)

RAF Lyneham was one of the RAF's largest operational bases for a number of years. (Courtesy of Richard E. Flagg)

The rifle range at Lyneham. (Courtesy of Richard E. Flagg)

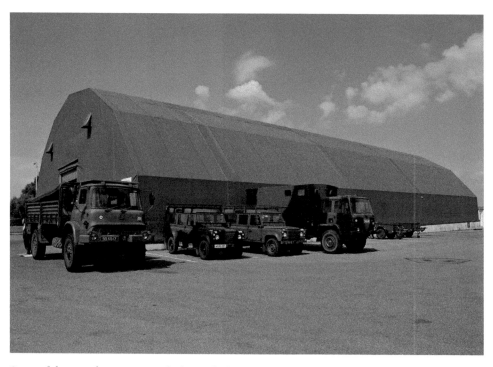

Some of the countless support vehicles at the base. (Courtesy of Richard E. Flagg)

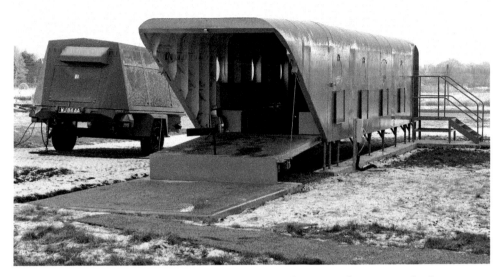

The Rotary Wing Training Facilitator based at RAF Lyneham is used to train Medical Emergency Response Team (MERT) personnel prior to deployment and is designed to the same dimensions as the interior of a Chinook helicopter. (Courtesy of Open Government Licence 3.0)

The main house at what was RAF Rudloe Manor. (Courtesy of Derek Hawkins CC BY-SA 2.0)

RAF Yatesbury

In 1916, farmland to the south of the village of Yatesbury was turned into an aerodrome for the newly formed Royal Flying Corps. Actually consisting of two airfields, an East and a West Camp, both with buildings and hangars, target areas were set out as pilot training began with No. 99 Squadron until the station was prematurely closed in 1920 in

the aftermath of the First World War. In 1936, the Bristol Aeroplane Company reopened part of the site as a civilian flight school, with trainees prepared for service in the RAF as the threat of the Second World War loomed large. It is interesting to note that legendary pilot Guy Gibson, leader of the famous 'Dambusters' raid in 1943, took his initial training here at the end of 1936! At the outbreak of the war the site was taken over by the Air Ministry to train airborne wireless operators, and from 1942, radar operators. No. 2 Radio School, as East Camp became known, had a certain Arthur C. Clarke (later to be a science fiction author and inventor) as one of its instructors. Although Yatesbury was primarily used for training purposes, it is estimated that around seventy servicemen from here died during the duration of the conflict, with a number buried in the village's churchyard.

The Cold War saw the continued training of radar operators, along with mechanics and fitters, and from 1954 to 1958, the site became known as RAF Cherhill, 27 Group Headquarters, Technical Training Command. The airfield closed in 1965 and in 1969 the vast majority of the land returned once again to farming, with all the wooden huts being demolished. Only a handful of brick structures remained and the two groups of hangars, dating back to 1916, and the former Officers' Mess and offices, built in 1936, were designated as Grade II listed buildings. Sadly, one hanger was demolished in 2012 because of its poor condition, whilst the other two remain standing and are currently on the 'Heritage at Risk' register. These remaining buildings are a testament to the courage and bravery shown by millions that ensured our freedom today.

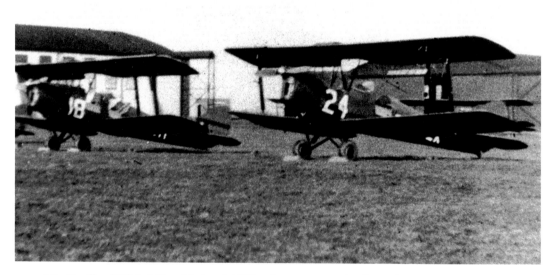

A De Havilland DH.82A Tiger Moth at RAF Yatesbury in 1939, taken by Sqdn Ldr Brian A. Hitchings on the occasion of his first solo flight. (Courtesy of the Dave Welch Collection)

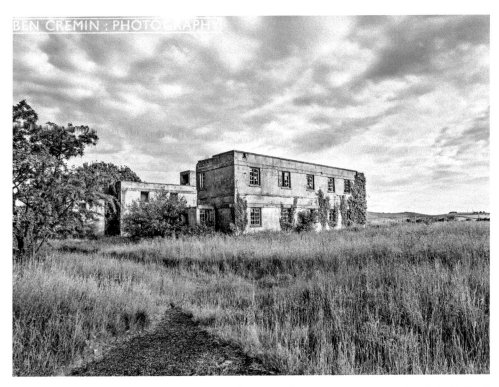

One of the many derelict buildings at the site of RAF Yatesbury. (Courtesy of Ben Cremin CC BY 2.0)

Some of these structures are now listed buildings. (Courtesy of Ben Mitchell CC BY 2.0)

REME Museum

The REME Museum of Technology is a fascinating place and really helps to preserve the history and heritage of the Corps of the Royal Electrical and Mechanical Engineers – after whom the museum is named. They were originally formed in 1942, with tradesmen being transferred into REME from other corps during the Second World War, as a way of keeping all aspects of the army, both tactical and logistical, moving forward in all conditions. The Royal Electrical and Mechanical Engineers are responsible for the maintenance, servicing and inspection of electrical and mechanical equipment used by the British Army, with only a few exceptions. As Montgomery put it, the REME exists 'to keep the punch in the Army's fist'. The museum began its life in 1958 in Arborfield, Berkshire, where it was originally located in just two rooms of Moat House – the former commander's accommodation of the Arborfield Army Remount Service Depot. However, by the very nature of the associated history of the REME, the museum expanded and they moved to a nearby building which allowed significantly more artefacts, objects and vehicles to be put on display. However, as part of the Defence Technical Training Change Programme, in April 2015 the museum closed its doors in preparation for a relocation from Berkshire to MoD Lyneham in Wiltshire, around 10 miles from Swindon. A former Officers' Mess at MoD Lyneham was restructured to provide a new home for the museum, and in the process, they redesigned the displays, added in more artefacts, and made the

The REME Museum of Technology has a whole range of vehicles on display. (Courtesy of Jamie Franklin CC BY-ND 2.0)

public facilities much better. With a shop, large café, an education suite with museum-led workshops available to schools and families, as well as conferencing facilities and a reading room for researchers! The museum opened its new doors to the public in June 2017 and has over 100,000 items within its displays and archives. It contains vehicles, uniforms, weapons and medals – as well as photographs and paperwork. MoD Lyneham is also the current regimental headquarters of the Royal Electrical and Mechanical Engineers, with the majority of the training taking place here.

Ringsbury Camp Hillfort

Believed to have been built around 50 BC, Ringsbury Camp is an Iron Age hillfort near the village of Purton that covers 8 acres. With excellent views of all the surrounding area, it is thought that all nearby trees were cleared to ensure this visibility was maintained and thus giving those in the hillfort clear view of anyone attacking. The hillfort is enclosed by earthwork banks made from limestone rubble, and it is really interesting to note that it is thought that these are not local rocks – meaning those who constructed it went to great lengths to transport them from further afield. Over the years, the centre of the enclosure was ploughed as farmland, and today, Ringsbury is used as grassland pasture and can be accessed by the public all-year round.

The ramparts of Ringsbury Camp. (Courtesy of Vieve Forward CC BY-SA 2.0)

Trowbridge

Trowbridge became an important industrial hotspot during the Second World War, as the town became one of five dispersed areas for Spitfire production in southern England, due to the heavy bombing of Southampton. Makeshift factories were set up, before a purpose-built factory was constructed in Bradley Road making the Mark V, IX, XII and XIV. Once built, the Spitfire parts were driven to an assembly hangar at the edge of RAF Keevil, where the wings and propellers were attached, and the aircraft then flown off to other airfields across the country. Trowbridge did receive some 'hit and run' attacks by the German air force during the war, with the town bridge and some buildings being hit.

Warminster

The town of Warminster is home to Battlesbury Barracks – built in 1965 with the Welsh Regiment being first on site. In 2005 the Duke of Wellington's Regiment returned here from being stationed in Germany, before being re-badged as the 3rd Battalion Yorkshire Regiment (Duke of Wellington's), and is currently the home of 1st Battalion Yorkshire Regiment. The barracks are built close to the site of Battlesbury Camp, an Iron Age hillfort on the edge of the town and on the border of Salisbury Plain that covers nearly 24 acres and is surrounded by at least a double earthwork ditch – and in some places a triple ditch. This is just part of the town's history though, as to the west of Warminster is the commanding Cley Hill, another Iron Age hillfort that rises over

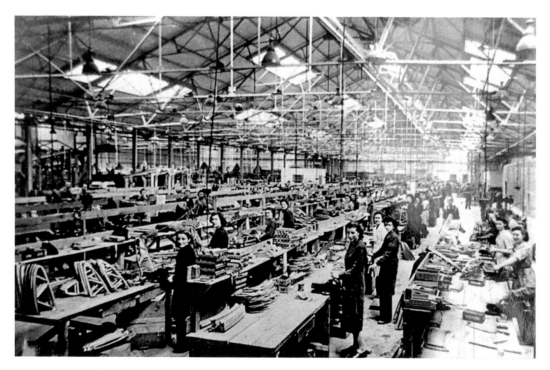

Women workers at the Trowbridge Spitfire factory.

200 metres up. During the First English Civil War, Warminster was under the control of the Parliamentarians, who became besieged by Royalist force, causing much damage to the town. In 1945, a School of Infantry was set up in the town – renamed the Land Warfare Centre in 1988 – and now known as Waterloo Lines, it is home to the 'Specialist Weapons School' which trains infantry weapons trainers, and is also the home to 'Headquarters Infantry' which is responsible for recruiting and training the infantry, Small Arms School Corps (SASC).

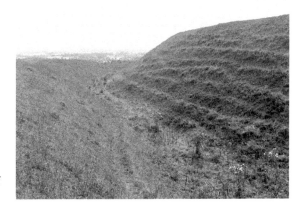

The earth walls and ditch of Battlesbury Camp hillfort. (Courtesy of David Hawgood CC BY-SA 2.0)

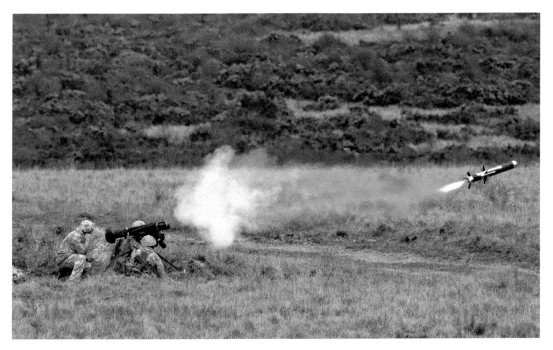

A demonstration of a Javelin, an Anti-Tank Guided Weapon (ATGW), at Imber Camp, Warminster. (Courtesy of Open Government Licence 3.0)

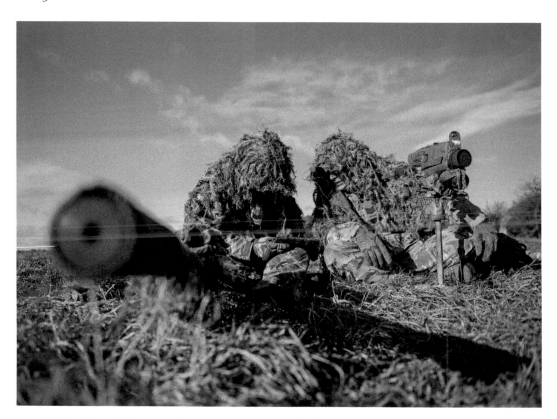

Soldiers from different regiments come together after being selected to attend the prestigious Sniper Commanders Course held at the Specialist Weapon School in Warminster. (Courtesy of Open Government Licence 3.0)

2. Swindon

Chiseldon Camp

Chiseldon Camp in Swindon was an important training facility and staging area in both the First and Second World Wars. Originally called Draycot Camp, it was bought by the War Office because of its location. It had good communication links by road and rail to all parts of the country, and the surrounding countryside was perfect for recreating the trench battlefields of France and Belgium, providing new recruits with valuable practice and experience. In fact, there was a full-sized trench system near Lower Upham Farm! Chiseldon Camp Halt was built, giving the camp its own railway station, and this was used to easily transport men and materials in and out of the camp. The first battalions that arrived slept in tents, but wooden huts were quickly built and soon there were over 100 buildings, including a workshop and a hospital in June 1915. The hospital received casualties from ambulance trains coming from Southampton dock throughout the remainder of the war, and also from its own camp, particularly when poor weather

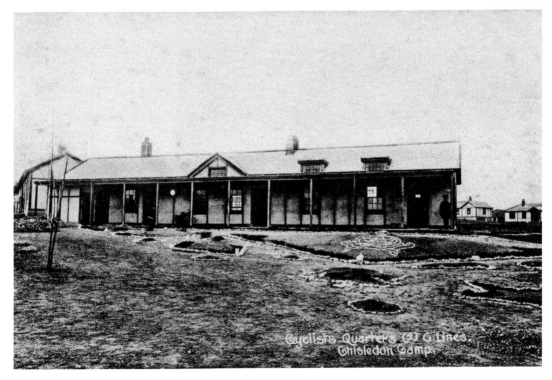

Chiseldon Camp during the First World War.

made parts of the site flood, leaving the men cold and damp. It is thought that up to 12,000 men could be here at any one time, with most coming in for fifteen weeks of training before promptly departing again. In 1917, the camp received some German prisoners of war, who were used for manual work, and at the end of the war, Chiseldon was used as a demobilisation centre for a staggering 10,000 men a day – the excellent rail links again coming to the fore! Although some of the camp was sold off after the war, part of the site remained as the School of Military Administration, training NCOs and Officers in operations and logistics. In 1939, the camp was again put on a war footing, becoming one of the collection points for some of the soldiers evacuated from Dunkirk, as well as providing combat training in the local countryside and vehicle driving. In 1942, Chiseldon had the distinction of being the first establishment to receive American troops, who used the facilities for various training activities.

The remains of the Chiseldon Camp Parade Ground. (Courtesy of Brian Robert Marshall CC BY-SA 2.0)

A view today of Chiseldon Camp Halt. (Courtesy of Brian Robert Marshall CC BY-SA 2.0)

The US built a new 750-bed hospital here 1943 and took a large number of D-Day casualties in June 1944 – the rail links to Southampton docks being vital yet again, with over 30,000 men being brought back here in the six months up to 1945. Once peace was declared, the hospital was closed and the camp rapidly emptied, being used for the demobbing of soldiers, but not on the scale of the First World War. A number of buildings were demolished in 1955, and the last army regiment stationed here left in 1962. The majority of the remaining buildings were demolished in 1974. Most of the site is now private property, but there is a memorial stone in place to mark the significant contribution made by Chiseldon Camp.

Liddington Castle

As the highest point in the borough of Swindon, the late Bronze Age/Iron Age hillfort of Liddington Castle is thought to have its origins in the seventh century BC, and as such, it is one of the oldest forts in the country. It is oval in shape, with two ramparts and a ditch that covers an area of three hectares. Wooden posts would likely have lined the top of the bank, adding an extra layer of defence to this hillfort, and standing there today, you get a really good sense of just how large and well defended this location was.

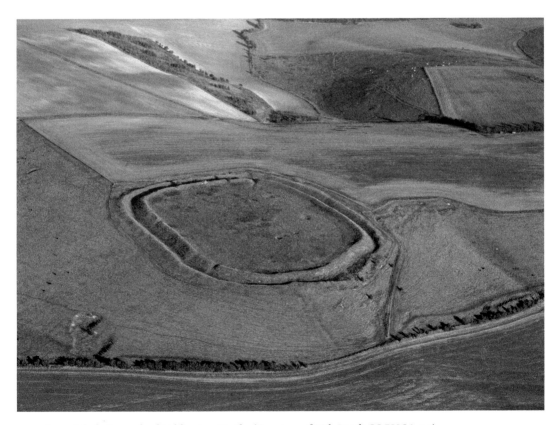

An aerial photograph of Liddington Castle. (Courtesy of Mik Peach CC BY-SA 4.0)

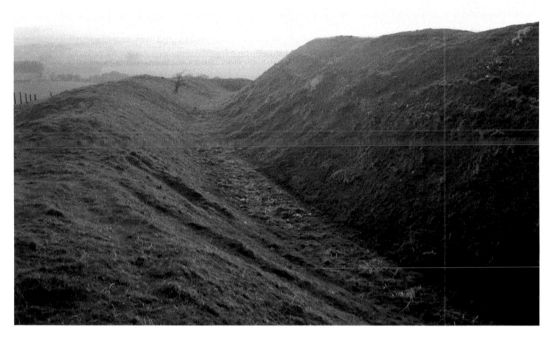

The large earthwork ramparts of the hillfort. (Courtesy of Philip Jelley CC BY-SA 3.0)

RAF Wroughton

Just to the south of Swindon, RAF Wroughton was opened on 1 April 1940 in response to the growing threat of a German invasion in the Second World War. Swindon itself was an important location for the manufacturing of aircraft parts, and as a result, RAF Wroughton was used for the assembly and storage of new aircraft before they were flown off to airfields right across the country for use. As the site was not used for operational contact with the enemy, it had a hospital built on its boundary. Opening on 14 June 1941, RAF Hospital Wroughton had a 1,000-bed capacity, and after the war it continued to treat military casualties as well as helping with the backlogs faced by the fledgling NHS in the Swindon area. In 1967, Princess Alexandra visited the hospital, and from then on it became known as RAF Princess Alexandra Hospital. In 1972, the site was handed over to the Royal Navy, becoming Royal Naval Aircraft Yard Wroughton, and this marked the end of aviation activity here. The hospital remained opened and in 1982, it received a number of casualties from the Falklands War, before closing in 1996 and being demolished in 2004. The site today is known as Alexandra Park and is owned by the Science Museum Group, with a museum and storage area on site.

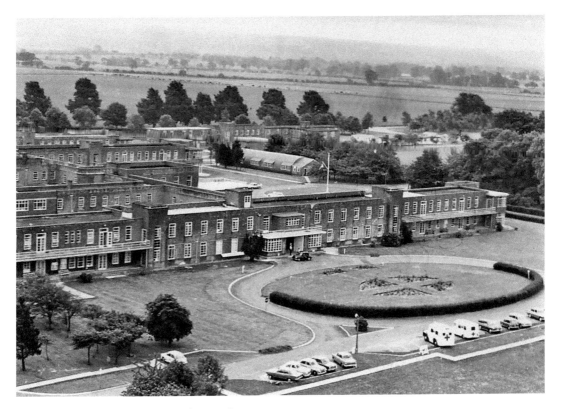

An aerial view of RAF Hospital Wroughton.

Nursing Course 42 from the early 1970s. (Courtesy of Linda Rogerson-Heath)

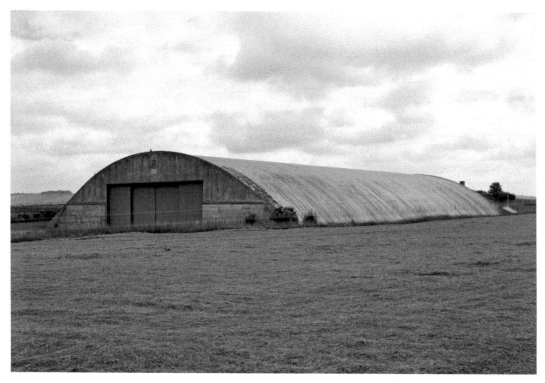

One of the many hangars that were on site. (Courtesy of Richard E. Flagg)

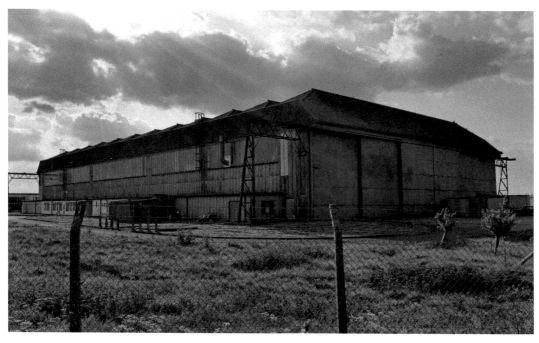

A type 'C' hangar at RAF Wroughton. (Courtesy of Jamie Franklin CC BY-ND 2.0)

Swindon

The First World War saw thousands of men leave Swindon and head off for fighting right across the world, with the 3rd Wessex Brigade of Royal Field Artillery and the Swindon Squadron of the Royal Wiltshire Yeomanry setting off, and a National Reserve set up in the town. Nearly 1,000 men from the town lost their lives during the conflict, new hospitals were set up in the town and a large military camp was established at Chiseldon. It is often overlooked that a number of refugees from Belgium were welcomed to the town, and the local industry supported the war effort. The Second World War saw evacuees from the big cities come here, and the town's industry stepped up to the mark once again, making many components for aircraft production which led to Swindon becoming a target for German bombers, with the town receiving a number of visits between 1940–41.

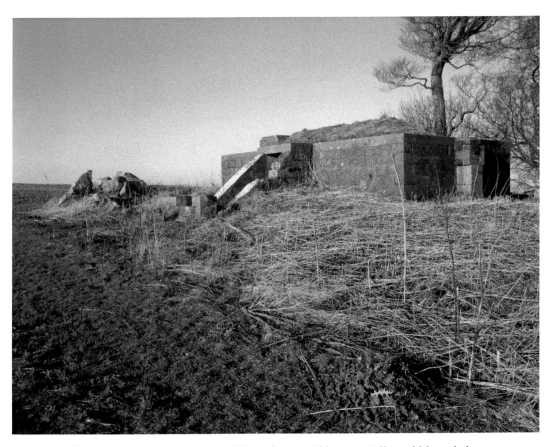

A bomb decoy site on the outskirts of Swindon at Liddington Hill would have led to some Luftwaffe raids dropping their payloads here instead of on the town. (Courtesy of Vieve Forward CC BY-SA 2.0)

3. Chippenham and South West Wiltshire

Battlesbury Barracks

There has been an army base at Battlesbury Barracks in Warminster since 1938, used mainly for logistical and operational purposes in the build-up to and during the Second World War. In 1965 it became the home for the Welch Regiment until 1969 when they amalgamated with the 1st Battalion The South Wales Borderers to form the 1st Battalion The Royal Regiment of Wales. In 2005, it became the new home for the Duke of Wellington's Regiment on their return from Belfast Barracks in Osnabruck, Germany, and since 2013 it has been the permanent base for the 1st Battalion, Yorkshire Regiment.

Battlesbury Camp

Near the town of Warminster are the remains of an Iron Age hillfort known as Battlesbury Camp. Covering an area of over 23 acres, like all hillforts, it uses the natural slopes and contours as natural defence, with an impressive three lines of ditches and ramparts encircling the vast majority of the site. Based on archaeological findings within the site, it is thought that the hillfort was constructed around 100 BC,

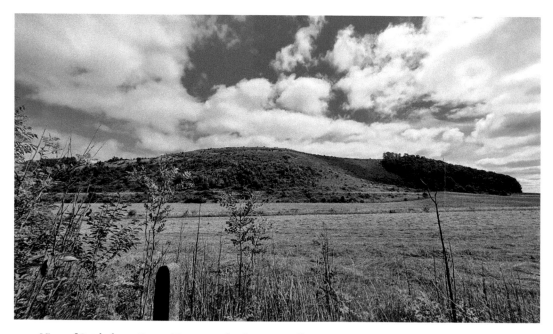

View of Battlesbury Camp. (Courtesy of Rebecca A Wills CC BY-SA 2.0)

with the earthwork parts possibly built on top of pre-existing burial mounds. Further excavations have shown that roundhouses and other structures were once constructed up here. Today, it is possible to freely access the site at any time of the year and take in the beautiful views.

Bratton Castle

On the western edge of Salisbury Plain, the 9-hectare Bratton Castle is an Iron Age hillfort that is surrounded by an earthwork bank and ditch. Although probably more well known by the later addition in the eighteenth century of the Westbury White Horse on its western side, Bratton Castle has three ancient barrows within or near its location and is thought to have been constructed to provide a defensive base for the locals mining iron from the area. Quarrying has taken place on the site since then, but despite this, it remains in good condition and anyone is able to visit at any time of the year. Nearby is thought to be the site for the Battle of Edington, also known as the Battle of Ethandun, where an Anglo-Saxon army under Alfred the Great defeated the Great Heathen Army led by Guthrum in May AD 878.

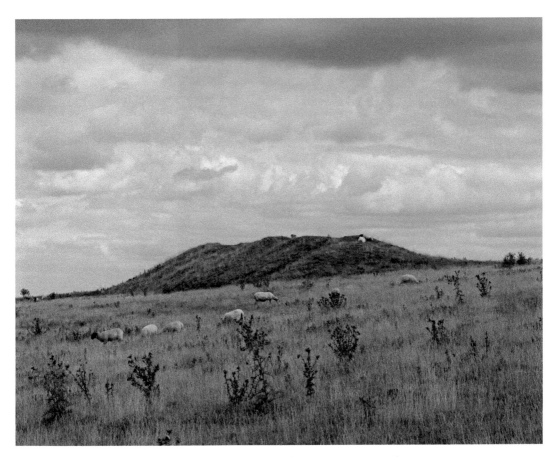

A view towards Bratton Castle. (Courtesy of Hugh Llewelyn CC BY-SA 2.0)

Bratton Castle earthworks. (Courtesy of Hugh Llewelyn CC BY-SA 2.0)

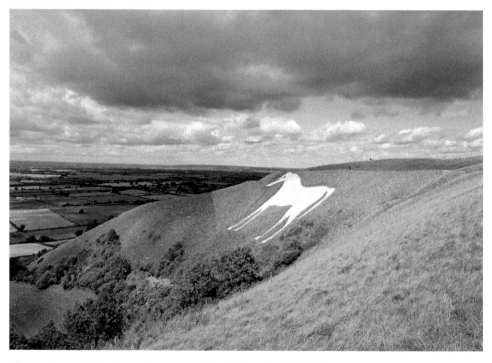

The Westbury White Horse. (Courtesy of Hugh Llewelyn CC BY-SA 2.0)

Castle Hill, Mere

In 1243, Richard the Earl of Cornwall acquired the village of Mere and began building a castle here in 1253 as a show of his power. Overlooking the village was a chalk ridge known as 'Long Hill', and this was quickly chosen as the site. The top of the hill was flattened, and a 5-metre ditch was dug along the western side, which is where the entrance was to be. Stone was imported from nearby quarries for the rectangular castle, which is thought to have had an impressive six towers, as well as inner and outer gates, a well, hall and chapel. In its day, it would have stood out for miles, dominating the landscape around Mere, and it is no doubt that the village grew significantly in size because of this. When Richard died in 1272, his son Edmund took control, and the manor of Mere continued to prosper until his death in 1300, when it was taken by the Crown. The castle was likely improved and renovated at this time due to the threat of rebellion in the country, but during the fourteenth century, the castle became abandoned due to its waning significance. It is said that Richard II took the lead from the castle roofs in 1398 in order to reuse it at Portchester Castle in Hampshire, and the stonework was taken over the years and used for new construction work in the town – leaving only the earthworks that we can see today. Now a scheduled monument, a flagpole and a memorial to the 43rd Wessex Infantry Division, which was constructed in the aftermath of the Second World War, are located on the castle site.

Cley Hill

Cley Hill, just to the west of Warminster, is yet another example of an Iron Age hillfort in Wiltshire. The summit of the hill is encircled by a number of earthwork ramparts that protect the centre and a number of Bronze Age barrows. Now listed as a Site of Special Scientific Interest (SSSI), it is maintained by the National Trust, and from the top you not only have spectacular views of the surrounding area, but also of Little Cley Hill, another Iron Age-developed mound.

Castle Hill overlooking the village of Mere. (Courtesy of Jamie Franklin CC BY-SA 2.0)

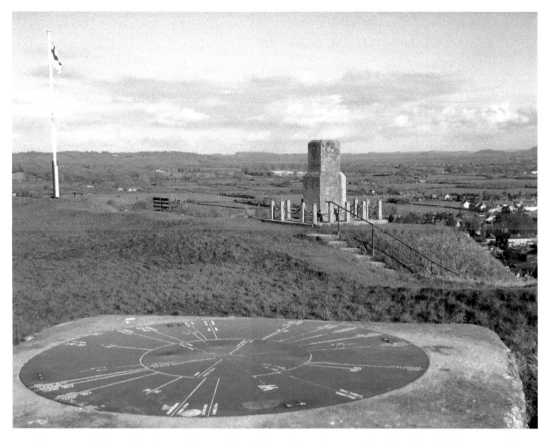

Toposcope, Wessex Regiment Memorial and flagpole at the summit of Castle Hill. (Courtesy of Colin Smith CC BY-SA 2.0)

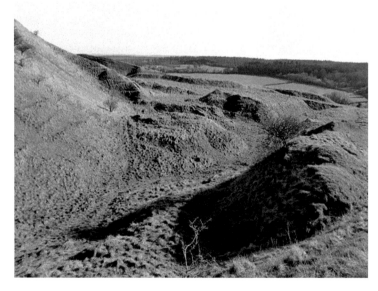

Evidence of quarrying on the southern side of Cley Hill. (Courtesy of Robin Webster CC BY-SA 2.0)

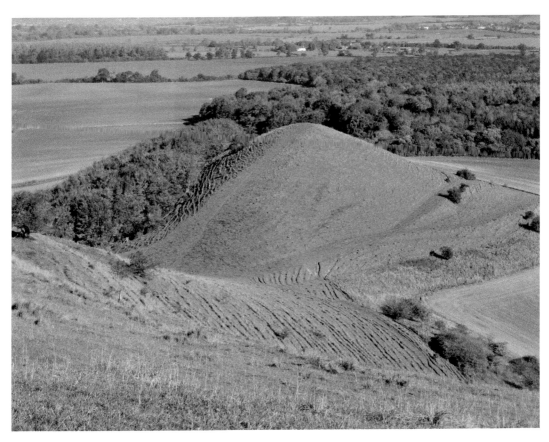

Looking down towards Little Cley Hill. (Courtesy of CC BY 2.0)

Codford Camp

In 1916 the village of Codford was chosen to become a depot, initially for New Zealand soldiers and later for Australian servicemen too, for men who were injured at the front line. A hospital was built here to deal with the returning casualties, built mainly of temporary wooden huts now long since gone. Within the village there is a Commonwealth War Graves Commission cemetery which contains the graves of 97 Anzac troops – sixty-six New Zealanders and thirty-one Australians, along with one from the Second World War. Stockton House was the headquarters of the Australian Brigade Commander and upon leaving the area, the 13th Battalion dug the Rising Sun badge into the hillside and this still stands as a reminder of their time here.

Grovely Castle Hillfort

Located near Steeple Langford, the Iron Age hillfort of Grovely Castle covers 13 acres and previous excavations here have proved it was a lived-in settlement, with five skeletons being discovered in the earth ramparts. Although farming and ploughing over the centuries have meant this site has suffered some damage, a central circular enclosure of 30 metres is evident, along with 3-metre-high ramparts and 1–2-metre ditches.

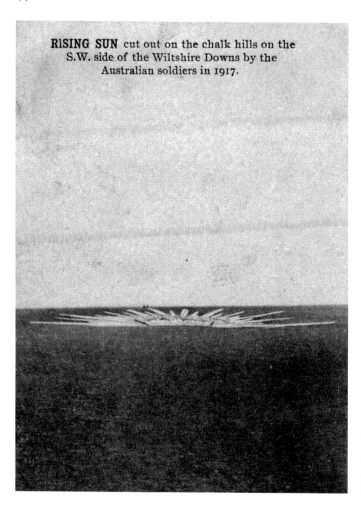

A postcard from *c.* 1917 showing the Rising Sun cut out on the chalk hills of the Wiltshire Downs by the Australian soldiers.

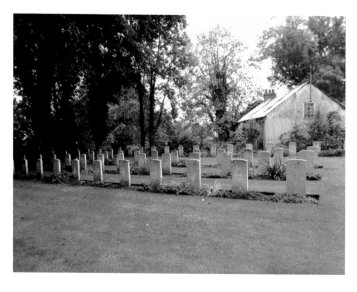

The Anzac Cemetery at Codford St Mary. (Courtesy of Basher Eyre CC BY-SA 2.0)

RAF Chilmark

As tensions rose between the First and Second World Wars, the Air Ministry purchased the disused quarries and surrounding land on the outskirts of Chilmark in 1936 and used the caverns and tunnels to store munitions. Home to No. 11 Maintenance Unit, the site became known as RAF Chilmark, and as well as using the underground caves, a vast amount of storage buildings were constructed in the woodland area that surrounded the site. In order to make the movement of ammunition easier, a specially built small spur and branch line was constructed on the London–Exeter railway near Ham Cross, meaning large amounts of materials could be transported easily to a huge covered shed in the quarry ravine. In 1985, a large underground bunker was also built in the ravine, ready to become the Regional Government Headquarters for the South West in the event of a nuclear attack, and this was operational until 1992. Throughout all this time, RAF Chilmark remained an ammunition supply depot until it was closed in 1995, when the site was then used by a private security company until 2015.

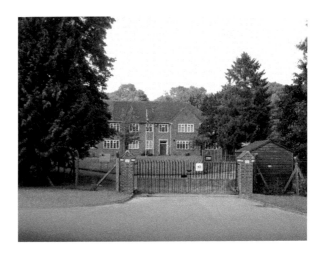

The former headquarters building at RAF Chilmark. (Courtesy of Andy Gryce CC BY-SA 2.0)

A large number of buildings now lie abandoned and derelict. (Courtesy of Andy Gryce CC BY-SA 2.0)

A section of the 2-foot narrow-gauge railway line that ran from Ham Cross into the underground storage areas of the limestone quarries. (Courtesy of Andy Gryce CC BY-SA 2.0)

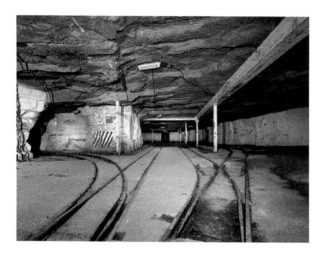

Part of the underground munition depot of RAF Chilmark. (Courtesy of Noel Jenkins CC BY-SA 2.0)

RAF Clyffe Pypard

In 1941, the unpaved RAF Clyffe Pypard was built as part of RAF Training Command. No. 29 Elementary Flying Training School was formed here in the September and the site was used to train pilots in a variety of aircraft, including Fairey Battles, Miles Magisters, Avro Ansons and de Havilland Tiger Moths. Although no fighting squadrons were stationed here, the training of pilots was absolutely crucial to the war effort, and many passed through this airfield during the course of the war, and the flying school remained in operation until it was disbanded in November 1947. After this, the site remained RAF property and staffed as the now-paved runways were still used as a satellite landing strip for other nearby RAF bases, becoming a transit camp for RAF Lyneham. Thousands passed through here over the coming years and it eventually closed down in 1961, when it was returned to farmland. A number of the buildings are still standing, some being used to house farm equipment.

It is still possible to see parts of the runway poking through the undergrowth. (Courtesy of Richard E. Flagg)

This hangar is now used to store farm equipment. (Courtesy of Richard E. Flagg)

Many buildings from the airfield's past can still be found. (Courtesy of Richard E. Flagg)

RAF Hullavington

On 14 June 1937, a new RAF training base opened on the outskirts of Chippenham, with No. 9 Flying Training School becoming the first to use the new facilities. The outbreak of the Second World War a few years later saw Blenheim bombers from No. 114 and No. 139 Squadrons arrive at the base, to move them away from their bases in East Anglia, for fear they would be attacked. Throughout the war, the two runways at the base were largely used for training; maintenance with No. 9 RAF Maintenance Unit; and No. 10 Group Communications Flight provided daily information about the weather, which was used by the Met Office for the wider military establishments across the country. After the war, the RAF continued to use the site for the training of gliders, parachutes and wider electrical understanding of aircraft. RAF Hullavington closed in March 1993, although the RAF retained part of the site for a glider school, before this too was sold off in 2016. The technical part of the site was taken by the British Army, renamed Buckley Barracks in 2003, and is the current home to 9 Regiment Royal Logistic Corps.

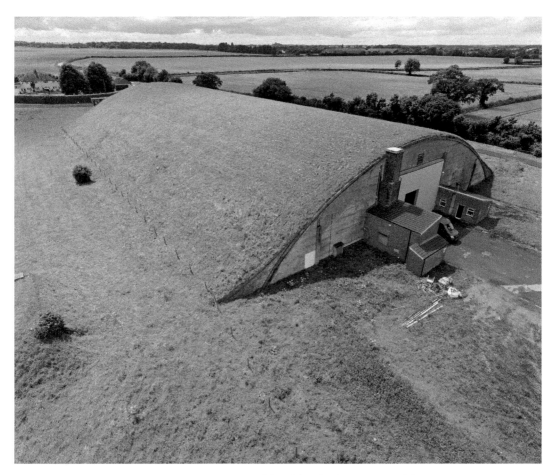

Many of the large hangars on the perimeter of the old airfield are now used by private companies. (Courtesy of Richard E. Flagg)

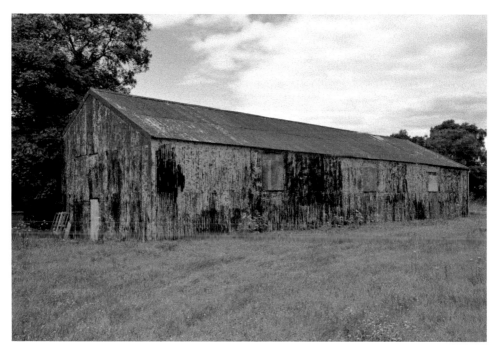

A number of buildings are now derelict. (Courtesy of Richard E. Flagg)

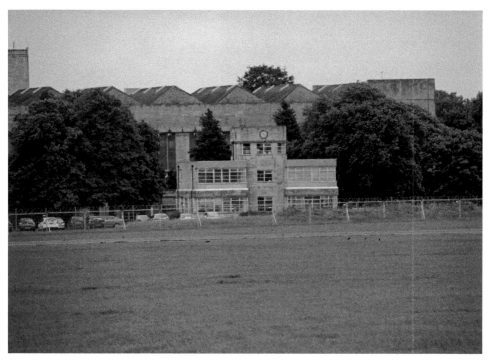

The old Watch Office and Chief Flying Instructors Block for service flying training, with huge hangars in the background. (Courtesy of Richard E. Flagg)

A view of the Headquarters of Buckley Barracks – formerly the Station Headquarters of RAF Hullavington. (Courtesy of Paul Shreeve CC BY-SA 2.0)

US Air Force members assigned to the 56th Rescue Squadron conduct post-flight inspections on an HH-60G Pave Hawk during exercise Voijek Valour at Hullavington Airfield, England, 3 March 2016. (US Air Force photo by Staff Sgt Emerson Nuñez – now Public Domain)

RAF Keevil

At the height of the Second World War, a 230-hectare site between the villages of Keevil and Steeple Ashton was chosen to be a new RAF base. Built in 1941, it was opened a year later in 1942 with three long concrete runways, which would allow larger transport and bomber aircraft to use the site. With the town of Trowbridge just a few miles away,

the Spitfire factory there would transport parts, including fuselages and wings, to an assembly building at the edge of the airfield near Steeple Ashton, before being flown off to different parts of the country. Although this continued throughout the war, the airfield was actually handed to the United States Air Force, with the 62nd Troop Carrier Group arriving here on 6 September 1942 with four squadrons, and using C-47 and C-53 aircraft to transport freight and supplies. In the December of that year, the 153rd Observation Squadron came to the airfield flying Douglas Bostons, Douglad A-20 Havocs and some Supermarine Spitfires. In December 1943, the Ninth Air Force 363rd Fighter Group briefly came to the airfield with three squadrons before moving on to Essex just a month later. In March 1944, the airfield reverted back to RAF control, with 196 and 299 Squadron from No. 38 Group arriving with their Short Stirling glider tugs and Horsa gliders. Crewed by personnel from many different countries, it is known that they facilitated SAS and SOE drops in France, and later that year, gliders and aircraft took off from here as part of the D-Day landings. September 1944 saw a large involvement from RAF Keevil in Operation Market Garden but by October 1944, with the liberation of Europe moving across the continent, the airfield took on a new role as a training base for gliders, and in 1945, for pilots of Spitfires and Mustangs. By 1947, RAF Keevil was no longer fully operational, used more on an ad-hoc basis until the 1960s for the US Air Force, and sometimes as a satellite airfield for aircraft at RAF Hullavington. Today, the airfield is in good condition. It is home to a gliding club and the perimeter track is occasionally used for motor sports. The army and RAF still hold regular exercises here, ensuring the legacy of this airfield continues.

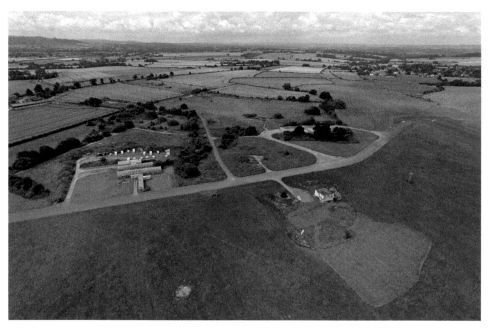

An aerial view of the old control tower and Second World War hangars that remain. (Courtesy of Richard E. Flagg)

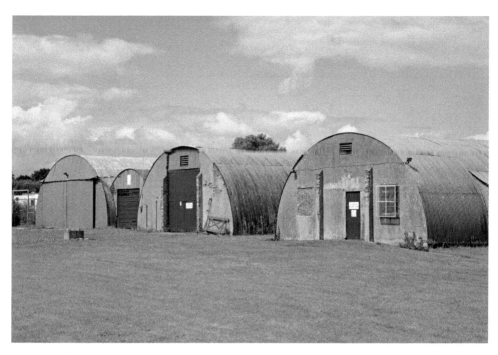

Associated buildings along the perimeter of the old airfield. (Courtesy of Richard E. Flagg)

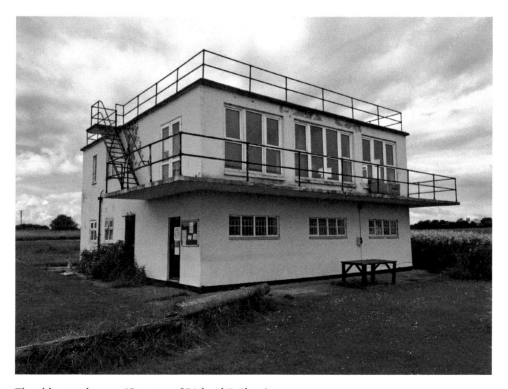

The old control tower. (Courtesy of Richard E. Flagg)

RAF Keevil Battle HQ from the Second World War. (Courtesy of Mike Searle CC BY-SA 2.0)

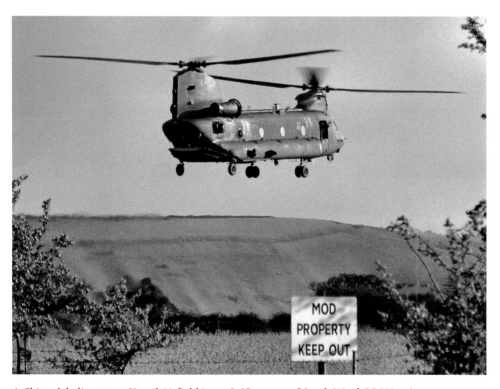

A Chinook helicopter at Keevil Airfield in 2018. (Courtesy of Sarah Ward CC BY 2.0)

An Airbus A400M Atlas at RAF Keevil during a training exercise. (Courtesy of Sarah Ward CC BY 2.0)

A TALO (Tactical Air Landing Operation) as part of exercise Joint Warrior. (Courtesy of Sarah Ward CC BY 2.0)

RAF Zeals

RAF Zeals, a new airfield on the vast Stourhead Estate, opened in 1942 with Hawker Hurricane and Supermarine Spitfires fighters playing their part in the defence of Britain and protecting shipping in the English Channel. In August 1943, it transferred to the hands of the United States Army Air Force, before returning once again to the RAF in March 1944 who used it as a fighter airfield to intercept German Bombers over the south of England. By the summer of 1944 it was used for glider training, and in April 1945 it became RNAS Zeals, as the Royal Navy took over and used the site for aircraft carrier training. Many different squadrons operated here during the Second World War, but the airfield closed in 1946 and was returned to farmland, which is how it remains today, with the control tower now a private house!

Scratchbury Camp

There is some debate as to whether this Iron Age hillfort can actually be dated to the Bronze age, due to a smaller enclosure being on top of the hill. Scratchbury Camp covers a large area of 37 acres on the summit of a hill that overlooks the Wylye Valley. It has one main rampart, which is between 3–6 metres in height, and a ditch of 1 metre in depth enclosing it. Excavations have found pottery and axes, and evidence of around 100 structures within the enclosed area. Now a scheduled monument, public footpaths mean that anyone can explore this ancient site.

The tarmac runway of RAF Zeals. (Courtesy of Richard E. Flagg)

The control tower is now a private house. (Courtesy of Richard E. Flagg)

Wardour Castle

Around 15 miles west of Salisbury are one of the most impressive sights in the county – the ruins of the fourteenth-century Wardour Castle. Its story began in 1385, when Baron John Lovell acquired the land and in 1392, King Richard II granted him permission to build a castle there. Wardour's six-sided design is unique in Britain and it is clearly inspired by the hexagonal castles that were in fashion at the time in parts of the continent – especially in France. The Lovell family supported the Lancastrian cause during the Wars of the Roses, and as a result, the castle was confiscated in 1461 by the state and passed through several owners until bought by Sir Thomas Arundell of Lanherne in 1544. This ancient prominent Cornish family owned much land in Cornwall and held several estates in Wiltshire. However, just eight years later in 1552, Sir Thomas was executed for treason and the castle was again confiscated. In 1570 it was bought back by his son, Sir Matthew Arundell, and life returned to normal for the next seventy years. At this point, the 1st Baron Arundell of Wardour, Thomas Arundell, was a very active Catholic landowner and with the onset of the First English Civil War, they naturally sided with the Royalists. During that war, the 2nd Baron Arundell of Wardour, also called Thomas, was away on the King's business, leaving a garrison of twenty-five trained fighting men to defend the castle and his wife, Lady Blanche Arundell. On 2 May 1643 Sir Edward Hungerford arrived with a Parliamentarian army of approximately 1,300 men. With those inside refusing point blank to allow them in to search for Royalist sympathisers, Hungerford laid siege to the castle, using guns and mines on its walls. After holding out for five days, Lady Arundell agreed to surrender, with the castle being placed under the command of

Colonel Edmund Ludlow. Lord Arundell died of his wounds after the Battle of Stratton that same month, so the son of Thomas and Blanche, Henry, 3rd Lord Arundell, brought a Royalist force to reclaim the castle. But this did not go exactly to plan. By November 1643 he had blockaded Wardour, but the excessive mining of the walls meant that most of the castle was blown up! The Parliamentary garrison did then surrender in March 1644, which was what he wanted, but sadly, he had very little of his castle left to reclaim! In the coming centuries the family slowly recovered some of their power, but it wasn't until the 8th Baron that they were able to finance rebuilding. The result was New Wardour Castle, much more of a stately home than a castle, and the ruined shell of Wardour Old Castle remained as an ornamental feature. On the ground floor you can get a sense of some of the rooms that were once there, with the stairs that once led up to the Great Hall. Very little remains of the upper rooms, which once would have been the most inviting part of the castle. Like the great hall, they would have been high rooms with an intricate wooden roof. It is still possible to view the surrounding woodland estate from the top and this gives you an idea of the power this castle and family once had.

Whitesheet Camp

Whitesheet Hill covers a staggering 336 acres of chalky downland within the Cranborne Chase and West Wiltshire Downs Area of Outstanding Beauty and is a biological site of Special Scientific Interest in its own right. There are Neolithic burial mounds here, along with the 2-hectare Iron Age oval hillfort of Whitesheet Camp. The oval-shaped hillfort has three ramparts and a ditch on the north and east sides, and a single rampart and ditch on its south and west.

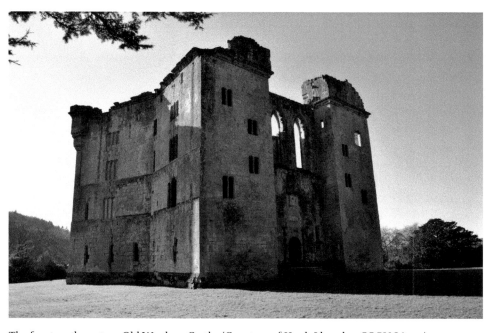

The fourteenth-century Old Wardour Castle. (Courtesy of Hugh Llewelyn CC BY-SA 2.0)

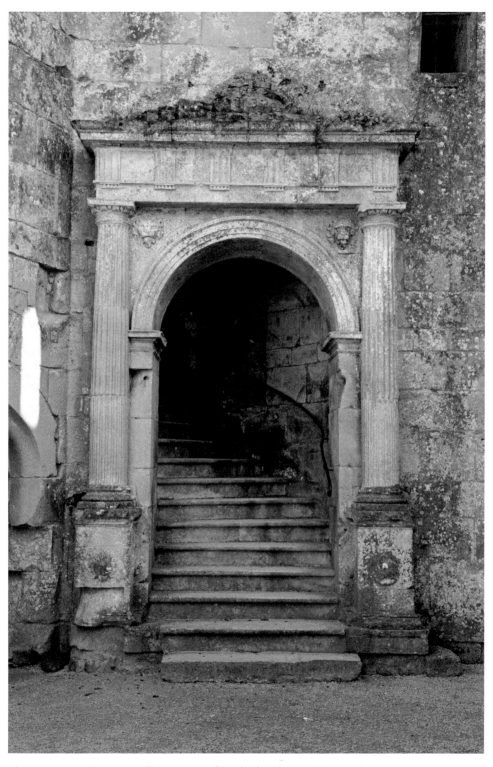

The entrance to the Great Hall. (Courtesy of Hugh Llewelyn CC BY-SA 2.0)

4. Devizes

Barbury Castle

Barbury Castle is one of the most impressive Iron Age hillforts in the entire country, let alone Wiltshire! Occupying a 12-acre site on the top of Barbury Hill, on the northern edge of the Marlborough Downs, it has two defensive earthwork ramparts and two deep ditches that would have provided very good protection to those inside. Excavations over the years have found evidence of the site being used by the Romans, and it is believed around forty huts were once inside the enclosure. Because of its height and location on the outskirts of Swindon, it is not surprising that the fort was used for anti-aircraft emplacements during the Second World War, with US anti-aircraft guns being deployed here to help protect the vital war factories of Swindon and the nearby airfields.

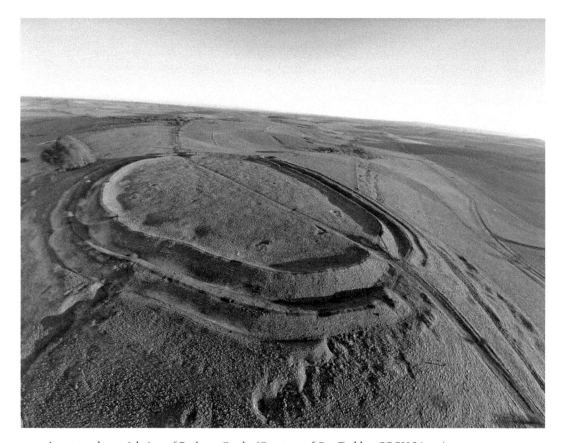

A spectacular aerial view of Barbury Castle. (Courtesy of Geo Trekker CC BY-SA 4.0)

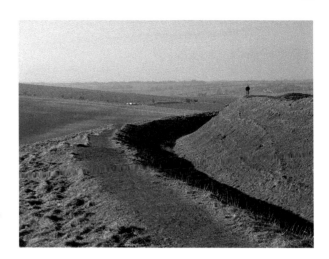

The earthwork ramparts are quite substantial! (Courtesy of Andrew Smith CC BY-SA 2.0)

Casterley Camp

Near the village of Upavon, Casterley Camp is a large Iron Age hillfort enclosure that is believed to have been used for stock control and religious purposes. An old track way, with earth banks on both sides, runs along one side and it is easy to imagine that this was a fairly important enclosure, that may have been well protected. Now a scheduled monument, it was partially excavated in the nineteenth century and on the other side of the River Avon, the smaller Iron Age hillfort of Chisenbury Camp can be seen.

Devizes Castle

The town of Devizes developed around a Norman motte-and-bailey castle that was built here in 1080 in the aftermath of the Norman Conquest. The castle must have been quite substantial as it held Robert Curthose (eldest son of William the Conqueror) as a prisoner in 1106, and there he remained for twenty years! Records indicate that the wooden structure burnt down in 1113 but was quickly rebuilt in stone by Roger of Salisbury in 1120. In 1141 the town was granted a charter permitting regular markets and these were held in the space that is now outside St Mary's Church, which quickly became the centre of the town. During the twelfth-century civil war between Stephen of Blois and Matilda, known as the Anarchy, the castle switched hands many times. Over the next 200 years, the town continued to grow as a centre of commerce for craftsmen and traders, with wheat, wool, cheese and butter being increasingly important. The castle remained the focal point for law and order over the town for the next few centuries but that changed in the aftermath of the English Civil War.

In 1643, Parliamentarian forces besieged the Royalist troops inside until they were relieved by a force from Oxford, which ensured Devizes and its castle remained in Royalist hands. However, in 1645, Oliver Cromwell attacked the castle with 5,000 men and heavy artillery, forcing those inside to surrender, and ultimately resulting in the castle being almost totally destroyed on the orders of Parliament in 1648, with the stone being reused for buildings in the town. The footprint ruins of the castle lay in the ground until 1838 when Devizes tradesman Valentine Leach purchased the land and built his own Victorian

era castle over the coming decades. The current castle, still privately owned but now a Grade I listed building, sits in over 2 acres of land with turrets, towers and castellations, and gives us a tantalising glimpse of what the original castle might have been like.

Battle of Roundway Down

On the outskirts of Devizes, within the North Wessex Area of Outstanding Natural Beauty, lies a vast open stretch of countryside where, on 13 July 1643 the Battle of Roundway Down was fought. It was the biggest cavalry victory during the First English Civil War, where the Royalist troops under the command of Lord Wilmot crushed a Parliamentarian force that was besieging Devizes. With the force approaching, the Parliamentarian troops broke their siege in the hope of defeating Lord Wilmot and his troops, but despite holding the high ground (which included 'Oliver's Castle', the site of an Iron Age hillfort, so named after Oliver Cromwell, although he was not at the battle), the Parliamentarians stood their ground, letting the Royalists attack first. This caused much confusion and allowed the Royalist infantry that was besieged at Devizes Castle to march up and support the attack. It is estimated that 600 Parliamentarian troops were killed and around 1,000 captured.

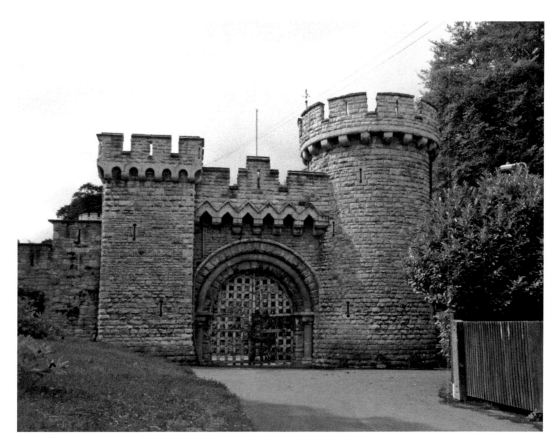

The gatehouse to Devizes Castle. (Courtesy of Hugh Llewelyn CC BY-SA 2.0)

Oliver's Castle, near Devizes. (Courtesy of Sarah J. Dow CC BY-ND 2.0)

Fosbury Camp

Also known as Hayden Hill Castle, Fosbury Camp is an Iron Age hillfort that covers over 25 acres of Knolls Down. It is easily accessed by public footpaths and is yet another example of the ancient people of Wiltshire defending themselves from attack and protecting their land.

Ludgershall Castle

The ruins of Ludgershall Castle in the far east of the county are all that are left of a castle built in the eleventh century by Edward of Salisbury, Sheriff of Wiltshire. By around 1100 it went into the possession of the Crown, and a man called John the Marshal (recorded as the king's castellan) is said to have strengthened the structure. At this point a northern enclosure was constructed on site, which contained all the important buildings, including a great hall and a tower with royal living quarters. King John then updated the site, transforming it from a castle to keep the population in check, to a hunting lodge in 1210. Ludgershall was an important place in medieval England, with King John's son, King Henry III, using it regularly. By the fifteenth century, the castle fell into disuse and like many buildings that had outlived their purpose, the vast majority of the stone was taken and used for other projects. The site was only excavated for the first time between 1964 and 1972 and was then listed as a Scheduled Ancient Monument in 1981. Significant earthworks remain, although they have been greatly altered by quarrying on the site, and parts of three large walls are left for you to visit today.

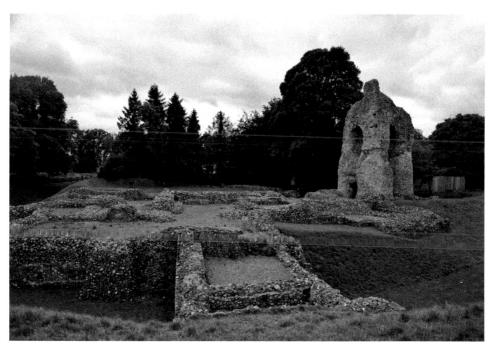

The ruins of Ludgershall Castle. (Author's collection)

Marlborough Castle

In the aftermath of the Norman Conquest, William the Conqueror assumed control of the Marlborough area in 1067 and built a wooden motte-and-bailey castle, sited on the prehistoric 'Marlborough mound'. As a result, the town is noted in the Domesday Book of 1087, and the castle was then completed around 1100. William established a mint in the town, nearby Savernake Forest became a royal hunting ground, and the castle became an official Royal residence! King Henry I spent Easter in the town, King Henry II often stayed at the castle, which was then strengthened in stone in 1175. King John was married here and spent time in Marlborough, where he established a Treasury and granted weekly markets to be held on Wednesdays and Saturdays – something that continues to this day. King Henry III married in the town and even held Parliament here in 1267! These 200 years saw the castle well maintained with an understandably strong garrison, but sadly, by the end of the fourteenth century, the castle had lost its importance, fell into disrepair and is said to have been in ruins by 1403. Like most notable towns, the English Civil War had an impact on the local population. The town was Parliamentarian, despite the Seymour family who had acquired the castle site being loyal to the King, and as a result in 1642, Royalist troops infiltrated the town down its small backstreets and alleyways. They looted what they could, set many buildings on fire, and marched over 100 miles to Oxford in chains. But the castle was now non-existent. The Seymour family had torn down the ruins and replaced them with a rather grand house, which today makes up much of Marlborough College – and the tree-covered earthworks mound is still easily notable within the grounds of Marlborough College.

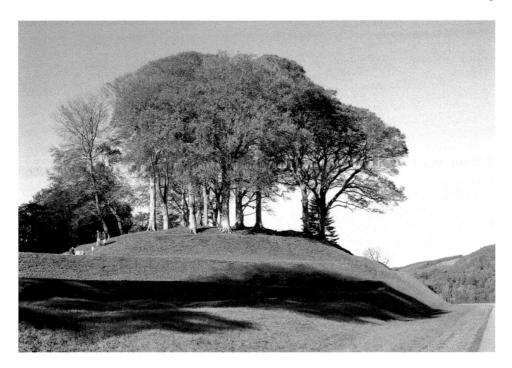

Above: Mount Marlborough – all that remains of the castle. (Courtesy of Billy McCrorie CC BY-SA 2.0)

Right: A public footpath leads to the circular earthworks, which are completely shrouded in trees. (Courtesy of Andrew Smith CC BY-SA 2.0)

Membury Camp

Located near the village of Lambourn, the 14-acre Iron Age-built Membury Camp sits on a small plateau right on the border with Berkshire, with the site being half in each county. A single circular ditch surrounds an area that measures nearly 400 by 500 metres, and although the earthworks are now covered in trees, it is still possible to easily work out the layout of the enclosure. A small portion of the eastern earthwork was destroyed with the construction of RAF Membury, but pottery and flint artefacts have been found here, meaning that this site was probably even used in Neolithic times.

RAF Ramsbury

Built in 1941 with the specific aim of facilitating the movement of vast numbers of troops in the Europe theatre of the Second World War, RAF Ramsbury was opened in 1942 and was immediately occupied by four squadrons of the USAAF Twelfth Air Force 64th Troop Carrier Group. Equipped with Douglas C-47s and C-53s, they flew cargo, passengers and courier missions, as well as ferrying paratroopers to North Africa as part of Operation Torch. From November 1943 to January 1944, the 434th and 435th Troop Carrier Groups participated in a lot of training with the 101st Airborne Division, later joined by the 437th Troop Carrier Group. The airfield was used a lot during D-Day, dropping paratroopers and transporting supplies across to Normandy, but in February 1945, the airfield became more of a reserve base as the American squadrons moved to France, before closing in 1946. Today, most of the airfield and its structures have gone, with a large poultry farm now being on the site, with just a few sections of runway and perimeter track left.

RAF Upavon

In 1912 the small village of Upavon, towards the edge of Salisbury Plain, became one of the first places to have an airfield constructed for the Royal Flying Corps (RFC). It became the RFC Central Flying School on 19 June 1912, with Captain Godfrey M. Paine of the Royal Navy in command, and Major Hugh Trenchard as his assistant – noteworthy

The runway of RAF Ramsbury. (Courtesy of Richard E. Flagg)

One of the few remaining structures still standing. (Courtesy of Richard E. Flagg)

as Trenchard would later become Chief of Air Staff and known as 'the father of the Royal Air Force'. It is here on the airfield's grass runway that the first night landing was made in England, and between 1914–15, two officers stationed here developed the bomb sight for planes, which was subsequently used at the Western Front in the First World War. When the Royal Flying Corps amalgamated with the Royal Naval Air Service to create the new Royal Air Force in April 1918, Upavon aerodrome became RAF Upavon. The Central Flying School remained, and during the 1920s, No. 17 Fighter Squadron RAF and No. 3 Fighter Squadron RAF moved here, developing, amongst other things, night flying and aviation fighting techniques. During the Second World War, RAF Upavon's primary role was to train and supply flight instructors to the military flying schools. The grass runway at the airfield was never really suited to heavier aircraft or those powered by jet engine, so after the conflict, Upavon became the headquarters for No. 38 Group as well as headquarters for RAF Transport Command. This saw new administrative buildings constructed, and flying display to mark the completion of these was held in June 1962. In the 1970s, No. 622 Volunteer Gliding Squadron, part of the Air Training Corps, moved here, and the airfield slowly became surplus to requirements. In 1993, the RAF officially handed over the site to the British Army and it became a British Army garrison called 'Trenchard Lines', which is still in use today, making the most of its proximity to Salisbury Plain.

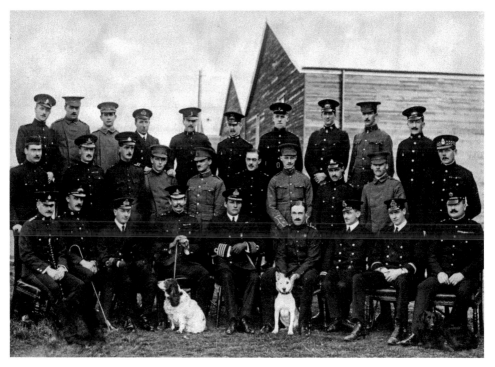

A group photograph of staff and pupils of the first course to pass through the Central Flying School at RAF Upavon, 17 August–19 December 1912. (Courtesy of Open Government Licence 3.0)

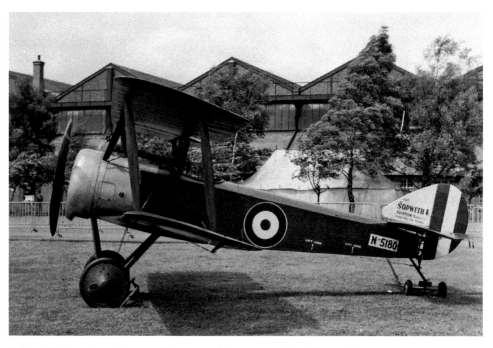

A Sopwith Pup at RAF Upavon. (Courtesy of the Dave Welch Collection)

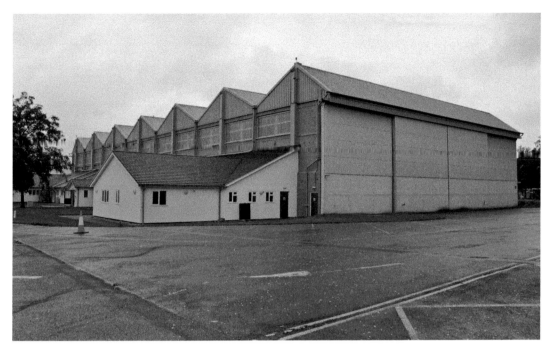

The hangars at former RAF Upavon. (Courtesy of Richard E. Flagg)

Inside the Trenchard Officers' Mess. (Courtesy of Richard E. Flagg)

Sidbury Camp

On the far eastern side of Salisbury Plain, Sidbury Camp is a 17-acre triangular Iron Age hillfort on Sidbury Hill. Perfectly placed for defence, it has steep slopes, a rampart and a double ditch that would have made it a well-protected and very large settlement. Although it is possible to access the site via public footpaths, the surrounding land is owned by the Ministry of Defence, and there are occasions when access to the earthworks may be restricted.

Tidworth Camp

At the turn of the twentieth century, Tidworth Camp was established on the site and grounds of Tedworth House, and a few years later, it became the home to Southern Command Headquarters. At the same time, Lucknow Barracks and Mooltan Barracks were constructed, and in 1907 a military hospital was built, which was then used during the First World War to treat those coming back from the Western Front. To the north of the camp, Tidworth Military Cemetery was established, and it contains the final resting place of 417 servicemen – mainly from Australia and New Zealand – and the rather grand Tedworth House was used for nurse's accommodation. A number of other barracks were constructed and named after battles in India and Afghanistan, along with a Royal Ordinance Depot. In the Second World War, the US 8th and 9th Armoured Divisions were stationed here, and the hospital continued to be used, with 106 graves located in the cemetery. The hospital closed in 1977, and although Southern Command HQ moved, the site continued to be vital during the Cold War. Between 2006 and 2014, Tidworth went through a huge refurbishment, and today is home to a number of regiments, including the Royal Tank Regiment, the King's Royal Hussars, the 1st Armoured Infantry Brigade and Headquarters South West.

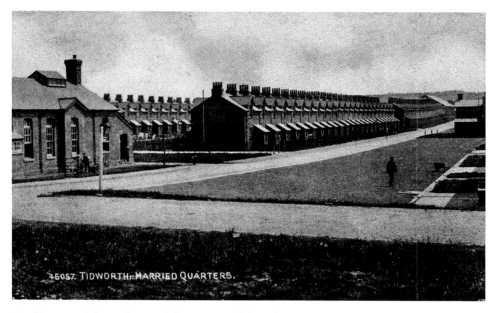

An old postcard shows the married quarters at Tidworth.

Lucknow Barracks is an
original building dating
from 1905. (Courtesy
of Andrew Smith
CC BY-SA 2.0)

Members of Y Company, 1st Battalion The Royal Regiment of Fusiliers, who are based at Tidworth
in Wiltshire. (Courtesy of Open Government Licence 3.0)

5. Salisbury

Boscombe Down Aviation Collection

Located in Hangar 1 on the site of the Old Sarum airfield is the impressive Boscombe Down Aviation Collection. Becoming a registered charity in 2011, the vast collection of aircraft, cockpits, replicas and equipment show the history of flight and flight testing in the UK – and particularly that of the Boscombe Down site. The site was first used by the military in 1917 when it was opened to provide a training facility for the Royal Flying Corps – the precursor to the Royal Air Force which was founded on 1 April 1918. Between 1934–37, the airfield was redeveloped as a permanent station in preparation for the Second World War, and more than doubled in size to 54 hectares. In May 1941 the base was attacked which resulted in one hangar and two aircraft being destroyed. After the war, the airfield was used by the military until 1979 and then used by a range of private companies and flying clubs, before closing in 2019. The aviation collection, which is still open, has a range of aircraft, engines, weapons as well as a display of uniforms, medals and artefacts from the Royal Flying Corps. It is possible to explore these aircraft chassis and sit in a number of cockpits on a visit, and it is so pleasing to see that a number of restoration projects are always on the go!

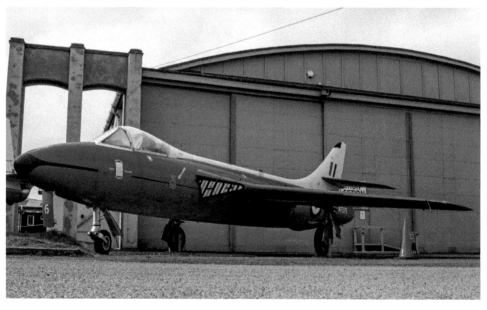

A Hawker Hunter F6 – part of the Boscombe Down Aviation Collection. (Courtesy of Steve Lynes CC BY 2.0)

Chiselbury Hillfort

Located near the village of Fovant, Chiselbury hillfort covers 10 acres and is enclosed by an earthwork rampart of nearly 4 metres in height, and a ditch of nearly 2 metres in depth. Although parts of the site have been damaged by farming, a number of finds have been found here over the years.

Defence Chemical Biological Radiological and Nuclear Centre

There has been some sort of military establishment at this site in Winterbourne Gunner, just a few miles north-east of Salisbury, since 1917, when it was a Trench Mortar Experimental Establishment. Then known as Porton South Camp, it was a trench mortar and artillery firing point, along with being an ammunition store and providing billets for troops. In 1926, it became the Chemical Warfare School, with training and demonstrations being provided for officers and senior non-commissioned officers. In 1931, it changed its status as it became the anti-gas wing of the Small Arms School, and at the outbreak of the Second World War in 1939, it became the Army Gas School, later renamed as the Army school of chemical warfare. In the years immediately after the conflict, it became the 'Joint School of Chemical Warfare', operated by the army and the RAF together. By the late 1950s, the school was renamed as the Joint School of Nuclear and Chemical Ground Defence, and by 1964, the title had changed again, to the Defence

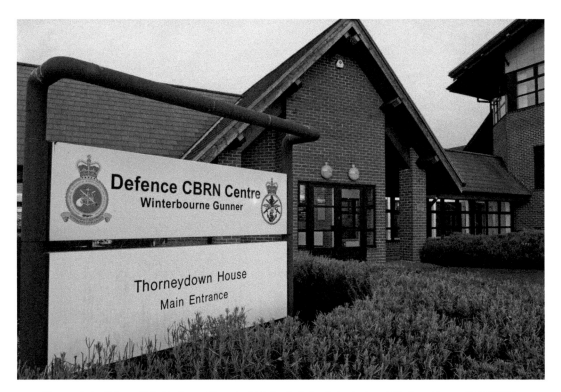

The main building of the Defence Chemical, Biological, Radiological and Nuclear Centre (DCBRNC). (Courtesy of Open Government Licence 3.0)

74

Nuclear, Biological and Chemical (NBC) School. A decade later it became the Defence NBC Centre, and these continual name changes represent the various emerging threats that Britain needed to be prepared for. In 2005, new state-of-the-art facilities were constructed, including a purpose-built training complex with headquarters, administrative buildings and the Defence CBRN School. At this time, it also changed its name to its current one, the Defence Chemical, Biological, Radiological and Nuclear Centre (or DCBRNC for short) in recognition of the change in focus from Cold War activities to a more wider threat, and it provides essential training for personnel across all British services and some NATO troops.

Fovant Badges
During the First World War, a number of soldiers from different regiments were garrisoned in the area around the village of Fovant, as a staging post before being sent across to France. Men from twenty of these units carved their regimental badges into the chalk hills of Fovant Down, and nine remain today, a lasting memory to their bravery and sacrifice.

Old Sarum
One of the earliest settlements in the country, let alone Wiltshire, it is thought that a Neolithic settlement on the hilltop may have been present here from possibly 3000 BC, with evidence of a protective hillfort being built here during the Iron Age in around 400 BC with gigantic banks and ditches surrounding the hill, measuring 400 metres in length and 360 metres in width. With a double defensive bank, the site was occupied during the Roman period, but interestingly, archaeologists do not think it was used by the Roman Army. It is known that Cynric, King of Wessex, captured the hill in AD 552, and centuries later, in 960, King Edgar assembled a national council at Old Sarum to plan a defence against the Danes. In the years that followed, it was abandoned and ransacked by the Danes in AD 1003. However, the defensive properties of the site were again recognised, and the Normans, only four years after the conquest of 1066, constructed a motte-and-bailey

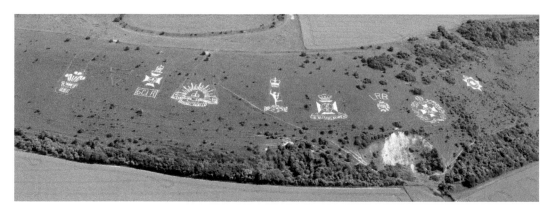

A stunning aerial view of the Fovant badges, taken in 2010 before the YMCA badge had been renewed. (Courtesy of Marchibald.fly CC BY-SA 4.0)

castle, and it is these earthworks and designs that remain so prevalent today. Held by the Norman kings themselves, Herman was installed as the first Bishop of Salisbury and together with Osmund, who was a cousin of William the Conqueror, they started the construction of the first Salisbury Cathedral. In fact Osmund, with all of his connections, was a very powerful man, and as Lord Chancellor of England he was responsible for the codification of the Sarum Rite and the compilation of the Domesday Book, which was probably presented to William I at Old Sarum in 1086! In the centuries that followed, a bigger town started to develop, with homes building up beside the ditch that protected the inner bailey and Norman castle, and kilns and furnaces being constructed. This saw Sarum's role as a castle diminish, and in the centuries that followed it fell into disrepair. By 1219, the decision had been made to relocate the cathedral, which was built within the castle walls, to a new location due to issues with strong winds, insufficient housing and that the soldiers of the royal fortress restricted access to the cathedral precinct. The inhabitants of the new city that was springing up around the new cathedral – Salisbury – gradually took the stone, wood and metalwork from the old cathedral and its castle, and in 1322 King Edward II ordered the castle's demolition. Today, the impressive earthwork defences and the stone footprint of the castle and its cathedral remain as a mark to this once important place.

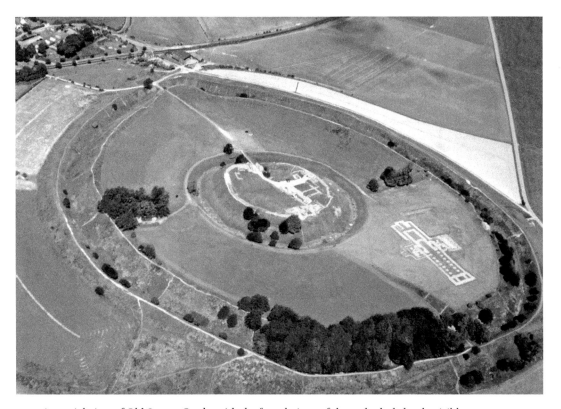

An aerial view of Old Sarum Castle, with the foundations of the cathedral clearly visible.

MoD Boscombe Down

The military testing site at MoD Boscombe Down began its life as Royal Flying Corps station Red House Farm in 1917 as a Training Depot Station. Aircrews were trained here for a range of operations for the remainder of the First World War, and after the conflict the site was used to store aircraft before being closed in 1920. In 1930, it was reopened as RAF Boscombe Down, with the heavy bombers of No. 9 and No. 10 Squadrons being the first to operate here, creating many offshoot squadrons over the following decade. At the start of the Second World War, the Aeroplane and Armament Experimental Establishment arrived, which saw the site used as a research centre and testing facility, which continued during the Cold War. In 2001, the two-runway site remained property of the MOD, but was operated by private company, QinetiQ, who have continued aircraft testing and development. A number of RAF units are still on site, including a pilots' school and test squadrons.

Porton Down

Just to the north of the village of Porton lies one of Britain's most secretive and sometimes controversial military research facilities. Porton Down is the home of the Ministry of Defence's Defence Science and Technology Laboratory (Dstl) and covers nearly 7,000 acres of the Wiltshire countryside. First opened in 1916 as War Department Experimental Station, it was then known as the Royal Engineers Experimental Station and it was responsible for the research and development of chemical weapons agents in the First World War. After 1918 work continued here, and by 1930 was renamed the Chemical Defence Experimental Station, where servicemen and civilian scientists worked together prior to and during the Second World War, with the focus of activities being on chemical weapons such as nitrogen mustard and anthrax. In the 1950s it became known as the

One of the hangars at MoD Boscombe Down. (Courtesy of Richard E. Flagg)

The Defence Science & Technology Laboratory (DSTL) facility at Porton Down near Salisbury. (Courtesy of Open Government Licence 3.0)

Microbiological Research Establishment, and later in the 1970s as the Chemical Defence Establishment. During this time, much was done to develop the understanding and control of chemical nerve agents, and controversy surrounds the reported use of human experimentation in doing this. It's most recent name change occurred in 2001 and the laboratory at Porton Down is now said to contain samples of some of the world's most aggressive pathogens (such as Ebola, anthrax and the plague), and is at the front of the UK's current research into viral inoculations.

RAF High Post

In 1931, the Wiltshire Light Aeroplane and County Club opened at High Post Aerodrome, located to the south-east of Great Durnford. By the mid-1930s, the Wiltshire School of Flying was based here, and with a runway of nearly 1,000 metres and a site covering an area of 110 acres, it is not surprising that the RAF took control of the aerodrome in 1940, officially becoming RAF High Post. Initially, 112 Squadron of the Royal Canadian Air Force (RCAF) came here with their Lysanders – an aircraft adept at flying short-range missions – and after the Battle of Britain and the subsequent bombing of factories in Southampton, some production of Spitfire aircraft moved to Salisbury, with High Post becoming an assembly and test centre for them in late 1940. In 1944, the grass runways were extended so it could become a Vickers' flight development site, with prototypes of the Spiteful and Seafang being built and tested here. After the war, RAF High Post was closed – due in part to the fact it was on the approach to the Boscombe Down testing site – with most of the site returning to farmland, and some buildings being used as small industrial units.

RAF Netheravon

At the end of the nineteenth century, in 1898, almost the whole of Netheravon Parish, including Netheravon House, was bought by the War Department in order develop a military base as part of the Salisbury Plain Training facilities. In 1904, a cavalry school was established under the sponsorship of Major General Robert Baden-Powell, who was the Inspector General of Cavalry, with the aim of teaching officers and NCOs newer and better methods of training men and horses in an effort to transform the role of cavalry in warfare before full-scale mechanisation took place. In 1912, the Royal Engineers Air Battalion took over some of the site, constructing hangars and an airfield which in 1913 became occupied by the Royal Flying Corps from Coulston Camp. The cavalry school continued to operate here until the beginning of the First World War, when it became known as RAF Netheravon and the home of No. 1 Flying Training School RAF from 1919 until 1931. During this time, in 1922, the cavalry school amalgamated with the Royal Artillery Riding Establishment in Northamptonshire, and as they left the location, it was soon taken over by a Machine Gun School, becoming a Small Arms School Corps in 1926. Over the coming decades, this was developed to include school all support weapons in general, becoming the 'Support Weapons Wing' of SASC. The Second World War saw the airfield more widely used for training with glider and parachute activity from 1941, with Netheravon House becoming the Officers' Mess. The Support Weapons Wing remained operational until 1995 and the airfield was used by the military up until 2012. Netheravon House, stables, grounds and dovecote are all Grade II listed.

Armourers maintaining guns at 6 Flying Training School, Netheravon, Wiltshire, 5 May 1937. (Courtesy of Open Government Licence 3.0)

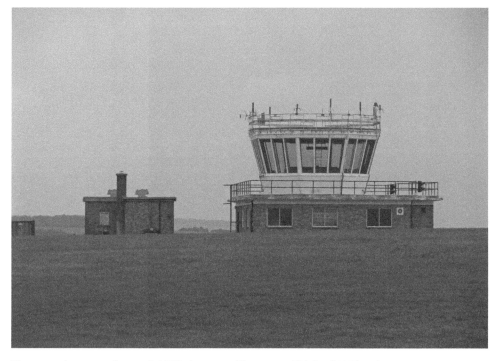

The control tower at former RAF Netheravon. (Courtesy of Richard E. Flagg)

Just some of the many buildings. (Courtesy of Richard E. Flagg)

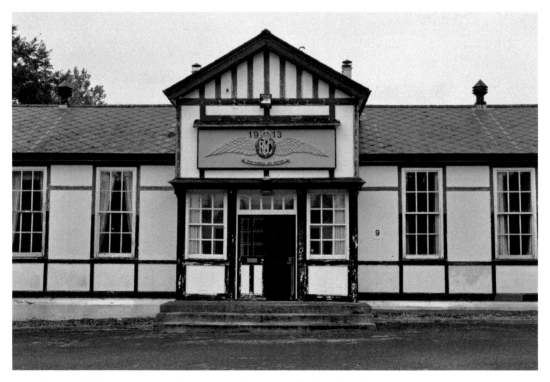

The Royal Flying Corps came here in 1913. (Courtesy of Richard E. Flagg)

RAF Old Sarum

In 1917, this site at Old Sarum was selected to provide facilities for a training station for the new Royal Flying Corps – the precursor to the RAF. Opened in August 1917, it was briefly known at first as 'Ford Farm', but soon took on 'RAF Old Sarum' as it became a base for the formation of three new day bomber squadrons. As the RAF was 'born' on 1 April 1918 a new flying training unit was formed at Old Sarum, 11 Training Depot Station, which was responsible for training new aircrews. After the First World War, the airfield was kept open, and became the home for the 'School of Army Co-operation' and in April 1924, 16 Squadron was reformed at Old Sarum for cooperation with Army units in Southern Command. With the apparent threat from Nazi Germany in the mid-1930s, Old Sarum Airfield was identified as being suitable for becoming a new permanent station. The site expanded from 19 acres to over 50 acres, with a whole range of new buildings meaning the site's primary role was that of training and developing ground support techniques. During the Second World War, the School of Army Co-operation was expanded, and significantly more aircraft became stationed here, with Hurricanes, Harvards and Tomahawks arriving on site. Old Sarum was one of the many countless bases that helped defend Britain from the skies in the early 1940s. By 1944, with plans for D-Day well advanced, all of the facilities at Old Sarum were requisitioned to form part of the 2nd TAF Concentration Area – essentially a supply location for the many ports and embarkation points of the ships and landing craft of the invasion forces – and all flight training was ended. Old Sarum certainly played its part in D-Day as thousands of ground personnel and virtually all RAF motor transport vehicles destined for Normandy passed

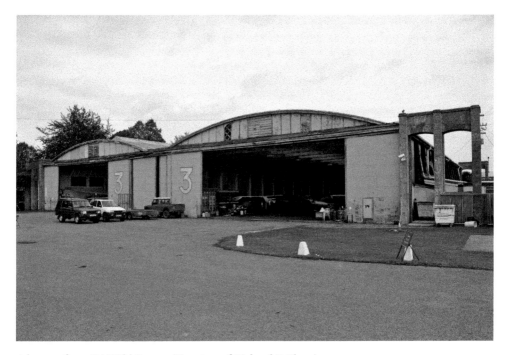

A hangar from RAF Old Sarum. (Courtesy of Richard E. Flagg)

through the location. After the war, the airfield was used by the military as the School of Land/Air Warfare and was the home to the Army Air Training and Development Centre. The base remained operational until 1979 and then used by a range of private companies and flying clubs, before closing in 2019.

RAF Shrewton

Built as a satellite airfield in 1940 for RAF Netheravon, RAF Shrewton was operated by RAF Flying Training Command and was used by a number of squadrons as a training base during the war. During the conflict, No. 1 and No. 15 Service Flying Training School, No. 43 Operational Training Unit, the Glider Exercise Squadron and the Heavy Glider Conversion Unit were stationed here. Aside from this, very little is documented about this training facility and after closing in 1946 it quickly reverted to farmland.

RAF Tilshead

Opened in 1925, the unpaved airfield near the village of Tilshead was operational until 1941 and only had a handful of squadrons there during its short life, due to the development of much larger bases nearby. No. 16 Squadron was based here between the August 1940 and September 1941, responsible for conducting reconnaissance of enemy movements in order to help protect the country from any potential invasion. No. 225 Squadron spent a short time here before the site was used for initial training for the Glider Pilot Regiment. Never really a permanent airfield, it was closed in 1941, and the location is currently used by the British Army as part of the Salisbury Plain Training Area, with nothing of note remaining of RAF Tilshead.

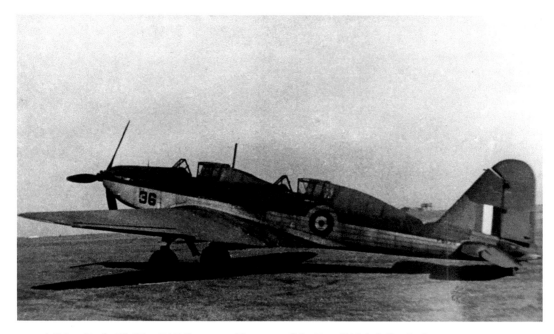

A Fairey Battle Mk IT at RAF Shrewton. (Courtesy of the Dave Welch Collection)

This memorial is all that marks the location of RAF Tilshead. (Courtesy of Richard E. Flagg)

Royal School of Artillery

Established in 1915 at Larkhill, the School of Instruction for Royal Horse and Field Artillery provided training for new soldiers and recruits coming into the army – using the vast open space of nearby Salisbury Plain. The site also had a 1,200-bed Fargo hospital that was used to tend to soldiers returning from the Western Front in the First World War. The site was expanded in the build-up, and duration, of the Second World War, with a new Officers' Mess and Quarters being built and thousands coming through here as part of their gunnery training. After the Second World War, the hospital was closed and that area became the main ammunition compound, and in the 1960s the camp was redesigned, and in 1970, it was re-designated the Royal School of Artillery. Today, it is the main training facility for new Royal Artillery recruits, which includes gunnery, air defence, surveillance and signals, and it is also home to the Gunnery Training Team.

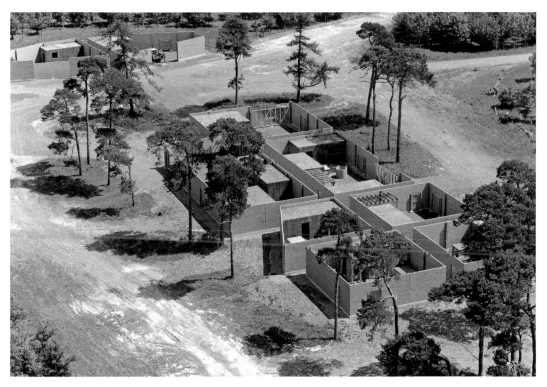

A picture of the Afghanistan Training Villages Area at Larkhill. (Courtesy of Open Government Licence 3.0)

Salisbury

One of the most historic and beautiful cities in the country, it is not surprising that Salisbury has its own military heritage. Originally known as 'New Sarum', it was designated a city by way of charter from King Henry III in 1227, and King Edward I met Robert the Bruce and others at Salisbury in October 1289, resulting in the Treaty of Salisbury. This potentially crucial treaty intended to guarantee the independence of Scotland after the death of Alexander III and accession of his granddaughter Margaret in 1286. It was hoped to end the competing claims of the House of Balliol and the House of Bruce to the Scottish throne and would in theory end any unnecessary bloodshed as seen in Wales a few years earlier. Signed by the Guardians of Scotland, Scotland was to remain 'separate and divided from England according to its rightful boundaries, free in itself and without subjection' – under the condition that Margaret would marry Edward's son. However, she died in 1290, rendering the treaty void, and Edward declared himself Lord Paramount of Scotland. Essentially ruling the country, despite John Balliol being announced as the heir to Scotland, the Scots formed an alliance with France which ultimately led to Edward invading Scotland in 1296. During the seventeenth century, Salisbury was chosen to assemble King James II's forces to resist the Glorious Revolution, and it is said that he arrived here with approximately 19,000 men on 19 November 1688. A number of his leading officers and even his own daughter Anne defected and joined

William of Orange and only a few days later on 26 November, James returned to the relative safety of London as he was unable to trust his own commanders. Despite his numerical superiority, he had decided not to attack the invading army, and in December he tried to flee to France. During the First World War, Salisbury Infirmary received a number of casualties to treat and although the fighting was on foreign soil, the conflict left its mark on the city with the number of locals killed – the War Memorial lists the names of 460 service personnel who died during this and subsequent conflicts. The Second World War saw the city on the receiving end of some occasional Luftwaffe bombing, but compared to other locations it escaped heavy bombardment. Today, it is home to The Rifles Berkshire & Wiltshire Museum and of course, has Salisbury Plain within a short distance away – both of which have their own entries here due to their importance.

Salisbury Plain Training Centre

Covering an area of around 150 square miles (roughly half of Salisbury Plain), the army has been using the vast open expanses of Salisbury Plain for military training since 1898. Public access is obviously restricted, and this huge setting has been at the heart of preparing British and Empire troops for battle since it was first used at the end of the nineteenth century. Salisbury Plain has a unique place in the country's military history as it has camps, training facilities and airfields scattered right across it. Around 47 square miles are used for live firing, with the Royal School of Artillery, based at Larkhill since 1915, using the area most days of the year. Much of the land is let for farmers to graze their animals on, but such are the size, scale and importance of many of the installations, most have their own entry in this publication.

The camps and barracks at Larkhill (Royal School of Artillery), Tidworth (Army), Upavon (Trenchard Lines) and Warminster (Waterloo Lines) are all situated to make the most of Salisbury Plain and are mentioned in separate entries. Bulford Camp is another installation, first constructed in 1897 and housed soldiers of the New Zealand Expeditionary Force during the First World War. To emphasise the scale of the camp, in 1906, the Amesbury and Military Camp Light Railway was extended from Amesbury into the heart of the camp, allowing personnel and goods easy access right up until 1933. Still in use today, the camp is now on two separate sites, and is home for the 3rd (UK) Division, 12th Armoured Infantry Brigade, 1st Battalion The Mercian Regiment and 5th Battalion The Rifles. Also on Salisbury Plain, between the small villages of Chitterne and Tilshead, is Copehill Down – a 'FIBUA' (Fighting In Built Up Areas) urban warfare and close quarters battle training centre. Here, various training, exercises and tests can be conducted in a specially created simulated backdrop, with a German village in Bavaria and a shanty town amongst the specific scenarios that were built. Another training area is that of the village of Imber. In 1943, it was evacuated to allow allied troops to begin essential training for Operation Overlord and has remained closed since. Still used by the military for training today, the village and the surrounding area is part of the Imber Range live firing area but is open to the public for an annual church service, usually in September, and some bank holidays. RAF Netheravon was in operation on the plain up until 2012, and nearby there are other significant military establishments, such as MoD Boscombe Down and Porton Down.

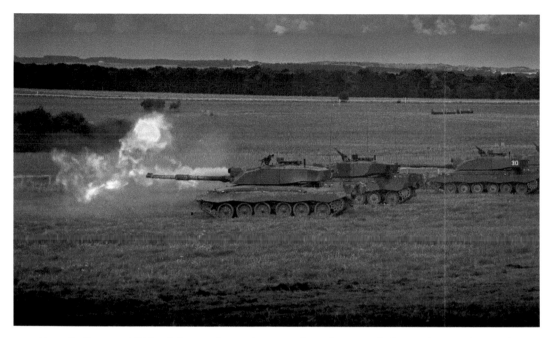

Four Challenger 2 MBT's of the King's Royal Hussars firing live rounds during the British Army's Combined Arms Manoeuvre Demonstration. (Courtesy of Open Government Licence 3.0)

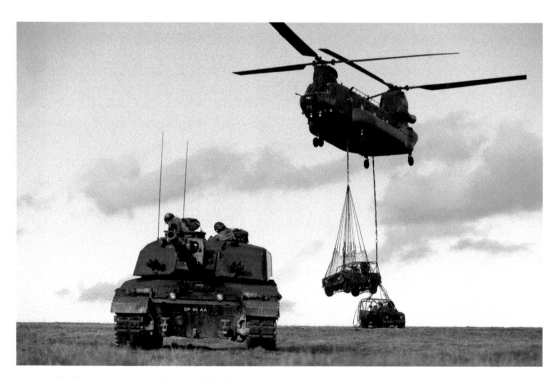

A Challenger 2 MBT and Chinook helicopter on the Salisbury Plain Training Area. (Courtesy of Open Government Licence 3.0)

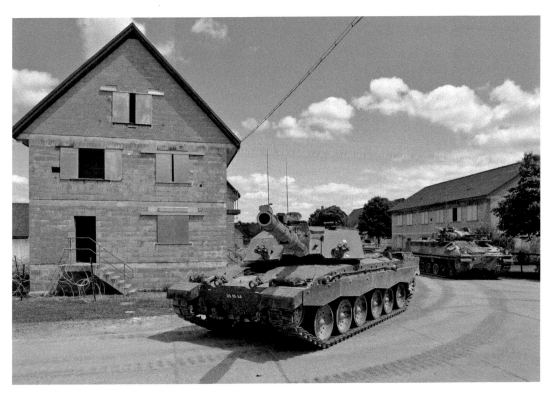

Copehill Down is a UK Ministry of Defence training facility located on Salisbury Plain. It is an urban warfare and close quarters battle training centre where exercises and tests are conducted. (Courtesy of Open Government Licence 3.0)

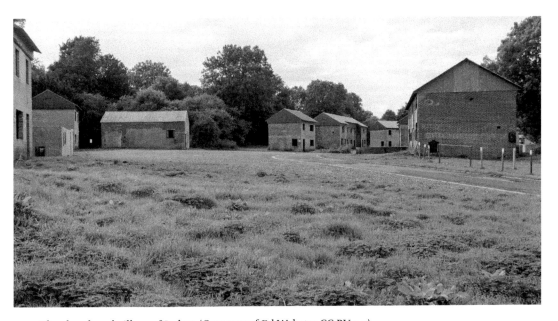

The abandoned village of Imber. (Courtesy of Ed Webster CC BY 2.0)

The Rifles Berkshire & Wiltshire Museum

Located in a Grade II listed building known as 'The Wardrobe' (as it used to house the robes of the Bishop of Salisbury), the Rifles Berkshire & Wiltshire Museum was originally opened in 1982 and has many exhibits about the Royal Berkshire Regiment and Wiltshire Regiment. The Royal Berkshire Regiment was formed in 1881 and has a long history of service, seeing active service in the Boer War, the First and Second World Wars, before amalgamating with the Wiltshire Regiment in 1959 and more recently, being amalgamated again to form 'The Rifles'. The Wiltshire Regiment has a similar tradition, seeing much active service across the empire with nearly 5,000 men being killed in the First World War and 1,000 in the Second World War, and has two of its own decorated with Victoria Crosses – one in each conflict. The museum has a staggering 36,000 items within its collection, over 1,000 of which are on display, ranging from uniforms and medals to weapons and flags. There is also an extensive collection of documents relating to the regiments and individual personnel.

Vespasian's Camp

Just inside the boundaries of the Stonehenge World Heritage Site sits Vespasian's Camp, an Iron Age hillfort that gets its name from the Roman general who campaigned through Wessex during the Roman invasion of Britain – but there is no evidence he ever came here! Covering an area of 37 acres, it is over 700 metres long and nearly 400 metres wide. It occupies a strong defensive position, with the River Avon to its south, a 10-metre-wide ditch and the main bank of earth 40 metres wide and 6 metres above the ditch, and you can imagine the difficulty in attacking this location. Based on archaeological finds, it's thought that the site has been occupied by humans for thousands of years, with animal bones and countless work tool amongst the discoveries. Although the site had a road built through it in the Middle Ages, and the Duke of Queensberry had part of it landscaped in the eighteenth century as it was part of the grounds around Amesbury Abbey, the earthworks are still clearly visible and are protected as part of the Stonehenge site.

All that's left of Vespasian's Camp.

Yarnbury Castle

The Iron Age hillfort of Yarnbury Castle near the village of Steeple Langford sits on private land and is a biological Site of Special Scientific Interest, due to the diversity of species found there – it is the largest area of calcareous grassland in north-western Europe. Thought to date from around 100 BC, Yarnbury Castle covers nearly 30 acres and has three ramparts with outer ditches. The outermost rampart is 3.5 metres high and the outer ditch nearly 2 metres deep, with the main entrance on the eastern side. A well-preserved site, there is archaeological evidence of there being long human settlement here, with Iron Age and Roman coins found here, as well as human burial remains. It is thought that there were around 130 structures here, and it is likely that such a large settlement would have seen a few attacks during its time as others sought to gain entry and take what was inside.

The steep banks of Yarnbury Castle. (Courtesy of Andrew Smith CC BY-SA 2.0)

Acknowledgements

Researching the history of an entire county is an exhilarating and time consuming process, but it has allowed me to discover new sights, sounds and many stories. In this day and age, it is possible to do a lot of research online, but nothing compares to actually heading out and exploring things for yourself. Only then, when you see the history in its original environment, does it start to make sense. Countless miles were driven as every location was visited, and a vast number of those in Wiltshire are free. Investigating the different aspects of this book has led me to find out some incredible things and meet a number of wonderful people, all of whom have been willing to share their knowledge and expertise, and this is so important in passing on the history of our communities to the next generation.

However, this book has not been without its challenges. Condensing the illustrious history of RAF Lyneham, for example, is difficult, and inevitably I have not been able to write about every single aspect of some locations. Nor has it been possible to write about all the individual stories or events that have unfolded over the centuries. It has also been very difficult finding out about some of the older locations, such as Iron Age and Roman forts, as often there are no remnants of the structures (barring earthworks – something Wiltshire has a lot of!) remaining, or they have been built on top of by more recent structures due to the prominent location. Indeed, the Second World War features heavily as it is the most recent conflict and many of these structures used pre-existing features as its base.

I need to express my gratitude to the organisations, people and photographers who have kindly shared their knowledge and allowed me to use their photographic work in my book. Thanks to Adrian Balch, Mike Dowsing, Dave Welch, and particularly Richard E. Flagg, who has kindly shared his photographs and knowledge, not just for this publication, but over a number of years and projects, and to whom this book is dedicated.

I would also like to thank Nick Grant, Nikki Embery, Jenny Bennett and all at Amberley Publishing for their help in making this project become a reality, as well as my wife, Laura, and young sons, James and Ryan, who accompanied me on many wonderful day trips across the length and breadth of Wiltshire, a county with beautiful scenery and a rich military heritage.

About the Author

Andrew Powell-Thomas writes military history, local heritage and children's fiction books. He regularly speaks at events, libraries, schools and literary festivals across the South West and lives in Somerset with his wife and two young sons. With more books and events planned, it is possible to keep up with everything he is up to by following him on social media or by visiting his website at www.andrewpowell-thomas.co.uk.

Andrew's other titles available with Amberley Publishing:

The West Country's Last Line of Defence: Taunton Stop Line
Somerset's Military Heritage
50 Gems of Somerset
Historic England: Somerset
50 Gems of Wiltshire
Cornwall's Military Heritage
Devon's Military Heritage
Castles and Fortifications of the West Country
50 Gems of Jersey
The Channel Islands' Military Heritage

Also available from Amberley Publishing

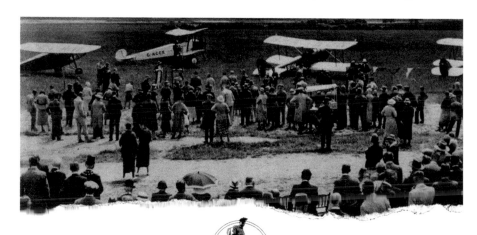

DEVON'S
MILITARY HERITAGE
ANDREW POWELL-THOMAS

Also available from Amberley Publishing

THE WEST COUNTRY'S LAST LINE OF DEFENCE

TAUNTON STOP LINE

ANDREW POWELL-THOMAS